IMAGES
of America

GERMAN MILWAUKEE

Wisconsin.

Ein Bericht über

Bevölkerung, Boden, Klima, Handel und die industriellen Verhältnisse

dieses reichen Staates im Nordwesten der nordamerikanischen Union.

Veröffentlicht von den

Staats = Einwanderungs = Commissären.

Zweite Auflage.

Milwaukee,
Schnellpressen-Druck des „Herold."
1868.

This cover is from a brochure in German for immigration to Wisconsin (1868). Germans were encouraged to immigrate to Wisconsin because they were considered good workers and orderly people. In fact, the State of Wisconsin even set up an immigration office in Germany specifically to attract Germans to the state. Milwaukee was one of the most popular destinations. (Courtesy of the Wisconsin Historical Society.)

On the cover: Pictured is a portrait of German painters relaxing in the studio of the American Panorama Company in Milwaukee. They are taking a break from painting the Jerusalem panorama depicting the crucifixion of Christ. (Courtesy of the Wisconsin Historical Society.)

GERMAN MILWAUKEE

Images of America

Edited by Jennifer Watson Schumacher

Copyright © 2009 by Jennifer Watson Schumacher
ISBN 978-0-7385-6037-3

Published by Arcadia Publishing
Charleston, South Carolina

Printed in the United States of America

Library of Congress Control Number: 2009920482

For all general information contact Arcadia Publishing at:
Telephone 843-853-2070
Fax 843-853-0044
E-mail sales@arcadiapublishing.com
For customer service and orders:
Toll-Free 1-888-313-2665

Visit us on the Internet at www.arcadiapublishing.com

Contents

Acknowledgments 6

Introduction 7

1. Germans Build Milwaukee 9

2. Religion and Education 29

3. The Politics of German Milwaukee 49

4. Industry and Business 61

5. The Art of German Milwaukee 79

6. The Social Scene 95

7. Women of German Milwaukee 109

8. German Americans During Wartime 117

Acknowledgments

This book has grown out of an upper-level University of Wisconsin–Milwaukee (UWM) German class titled German Milwaukee. Students in this course were interested in their own German heritage in the city as well as the "Germanness" of Milwaukee in general. We have learned a great deal, much of which we were not able to include in this book. Others have written on specific topics of Milwaukee's Germanness, such as the food, clubs and societies, and businesses. We have tried to present different facets of German influence in the city, hitting on interesting points but certainly not covering any topic completely. There is so much that German Americans have contributed to the city of Milwaukee that it would take a book on each chapter to be anywhere near thorough on the subject of German Milwaukee. We have concentrated on the earlier influence of German immigrants in Milwaukee, not on those who came during or after the wars who have also added to the colorful fabric of the city. We have done our best and hope that it will bring enjoyment to the reader and an appreciation for the German immigrants of Milwaukee.

We are indebted to many people, including Dean Richard Meadows and UWM's School of Letters and Science; Dr. Nigel Rothfels and UWM's Office of Undergraduate Research; Matthew E. Anderson, who formatted and advised on the book; UWM's German program; Steve Walker and the Milwaukee County Historical Society; the Wisconsin Historical Society; and the Max Kade Institute.

INTRODUCTION

Although the urban myth that the German language lost being the United States' primary language by one vote is just that, a myth, it demonstrates the importance that German immigrants played—and still do play—in American life. German immigrants were some of the first settlers in the United States. They played a key role in the settling of Jamestown, were soldiers in the American Revolution, and contributed to the exploration and expansion of the country.

German immigrants first arrived on American soil in the early 1600s. By the 1800s, particularly the mid- to late 1800s, Germans were arriving in the United States in large numbers, and many of these immigrants were heading to Wisconsin, a newly settled territory that offered them inexpensive land—$1.25 an acre—and fluid social conditions. They were specifically drawn to Milwaukee because it was a well-advertised boomtown and because the forests of southeastern Wisconsin reminded many of their homeland. The first notable group of Germans in Milwaukee was "Old Lutherans" (approximately 500) from Pomerania who arrived in the 1830s. They were fleeing the royal attempt to meld them with Reformed Protestants in a Prussian state church, and they saw the Milwaukee area as a utopian haven where they could practice their religion as they wanted to. They founded the town of Freistadt (literally "free city"). With increased political unrest in Europe, particularly the revolutions of 1848 in the German states (hence the term 48ers) in which the hope for a constitutional government was crushed, German immigration to the United States, and specifically to Milwaukee, increased greatly. Some 1,200 German immigrants were arriving in Milwaukee weekly. By 1859, Germans were the largest immigrant group in Milwaukee, making up one-third of the population. German language and culture could be found everywhere. School lessons were held in German. Political speeches, newspapers, and advertisements were written in German. Stores had to advertise that they spoke English to attract non-Germans. There were German theaters, such as the Stadt Theater (later the Pabst Theater), which not only presented German drama but also English-language drama translated into German (for example, Shakespeare); German artists; musical groups, such as the Musikverein von Milwaukee (Milwaukee Music Society) and *Liederkranz* (choral society); and athletic clubs such as the *Turnverein* (gymnastics club). Beer gardens sprang up across Milwaukee where, much to the horror of the Anglo-Saxons, Germans even congregated on Sundays to drink beer and socialize.

Still today 48 percent of the population in Milwaukee claims to have German ancestry—the largest percent in the country. And still today the influence of the German immigrants in Milwaukee can be seen in the fabric of the city. From the numerous German churches, such as St. Mary's, to the Germania Building, to city hall, German influence on Milwaukee architecture can be found throughout the city. Germans are credited with bringing socialist doctrine to

7

Milwaukee—over decades, the city elected a number of socialist mayors and sent the first socialist congressman to Washington (early 1900s). The influence of the socialists can still be seen in the city's numerous and large public parks, which are free and open to all (including Washington Park with the large statue of Schiller and Goethe). The first kindergarten in the country can be found just outside Milwaukee, in Watertown. The Pabst, Miller, Uihlein, Pfister, Brumder, and other financially successful German families not only helped establish Milwaukee as a major industrial center, they also contributed greatly to the politics and art of the city. German industries such as breweries and tanneries gave Milwaukee its solid industrial base, employing a large number of Milwaukeeans for decades. Milwaukee has the biggest German festival in the country, numerous German restaurants, and more German clubs, choirs, and organizations than can be kept track of, and many of them date back to the 1800s. There is a reason that Milwaukee was known as the "German Athens" and that even today it is recognized nationally as one of, if not the, German cities of the United States. German Americans travel across the country to Milwaukee (often for Germanfest), looking for their American story, that is the story of German immigration—the hopes, dreams, and successes of Germans in America—and to discover (or rediscover) their Germanness. It is here in Milwaukee.

One

GERMANS BUILD MILWAUKEE

The skyline of Milwaukee reveals a rich German heritage in religious, public, commercial, and private buildings.

The churches, such as St. John's Cathedral (1847), Old St. Mary's Church (1848), and Holy Trinity Church (1849), are among the oldest surviving structures in the city. All three were built in the German Zopfstil, which is considered the last vestige of Renaissance architecture. German Gothic style also played a main role in shaping Milwaukee's religious skyline. Trinity Lutheran Church (1878) is considered the mother church of Lutheranism in Milwaukee. And Germanic Gothic influence can also be seen in Grace Lutheran Church (1850) and St. Stephen's Lutheran Church (1901), as well as St. Michael's Roman Catholic Church (1892).

Many German American architects played a role in the religious landscape of the city. Henry C. Koch emigrated from Germany with his parents as a child, was educated in the United States, and then apprenticed with the well-known American architect George W. Mygatt. In Milwaukee, Koch created the Roman Catholic Church of the Gesu (1893), Calvary Presbyterian Church (1870), and St. Matthew's Lutheran (1875). He also designed Milwaukee's most unique landmark, city hall (1891), as well as Turner Hall and the Pfister Hotel.

Otto Strack is another prominent German American architect of Milwaukee. Strack was born in Roebel, Germany, and came to Milwaukee in 1888 where he trained to be an architect. Perhaps his greatest achievement in the city is the Pabst Theater. Funded by Frederick Pabst, Strack created a theater reminiscent of the German Renaissance Revival style with apparent baroque influence.

German architectural design can also be seen in some of the details of the great Milwaukee homes. Perhaps no other building stands out like the Pabst mansion. German American Rev. Frederick Pabst, one of the prominent Milwaukee Germans in the 1890s, commissioned the mansion in 1892, wanting to maintain his Germanness in the details of his home. Others that have a very German appearance include the Machek residence (1886), the Kalvelage home (1895), and the Harnischfeger house (1905).

Milwaukee is full of buildings, homes, and churches created by German Americans who built a city reminiscent of their homeland.

—Melanie Anke and Zlatko Sadikovic

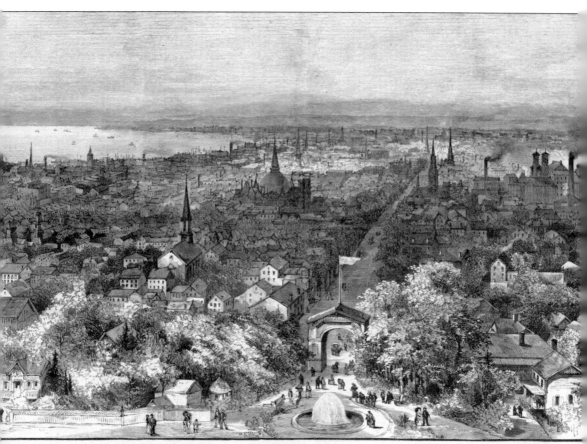

This 1882 bird's-eye view shows Milwaukee looking south down Eighth Street from Schlitz's Park. Already at this time German Americans had left their stamp on the architectural landscape of Milwaukee. (Courtesy of the Wisconsin Historical Society.)

St. John's Cathedral is located on North Jackson Street. It was designed by Victor Schulte, who was born in Germany and started his career as a carpenter and builder. The original church had a bulbous tower cupola, which could also be found in German and Austrian towers of the 18th century. Due to the rotting away of the underneath frame of the cupola, in 1880 it had to be removed. It should be noted that the tower is regarded as a masterpiece and is probably the most photographed in the Midwest. Unfortunately, disaster struck in 1935 and the church burned down. Precious stained-glass windows, paintings, and a valuable pipe organ were forever lost. Restorations were completed in 1942 by a design by William R. Perry. (Courtesy of the Milwaukee County Historical Society.)

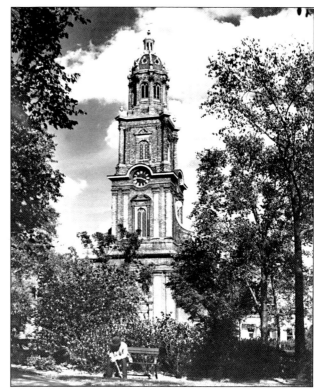

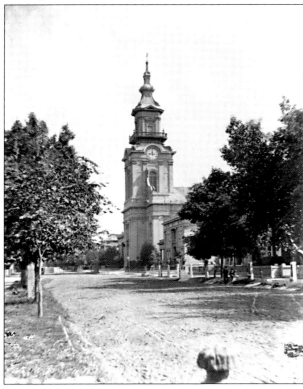

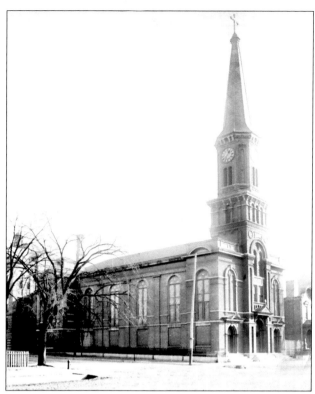

Old St. Mary's Church was the first German Roman Catholic church in the city and is located on the corner of North Broadway and East Kilbourn Avenue. Over time the church underwent multiple renovations. The original octagonal cupola was replaced with a speared brick tower on the west front. The interior was also renovated, and a new tower was built. In 1867, the front and back of the church were also extended. (Courtesy of the Milwaukee County Historical Society.)

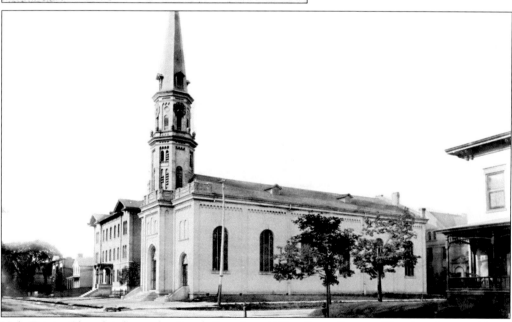

Holy Trinity Church is located at South Fourth and West Bruce Streets. The church was without a steeple for quite some time. Architect Leonard Schmidtner created the missing piece, which was finally added in 1862. It was followed by the tower clock in 1869. Its unusual matched pair of cornerstones, which can be seen at the base of the buttress flanking, make it one of a kind. (Courtesy of the Milwaukee County Historical Society.)

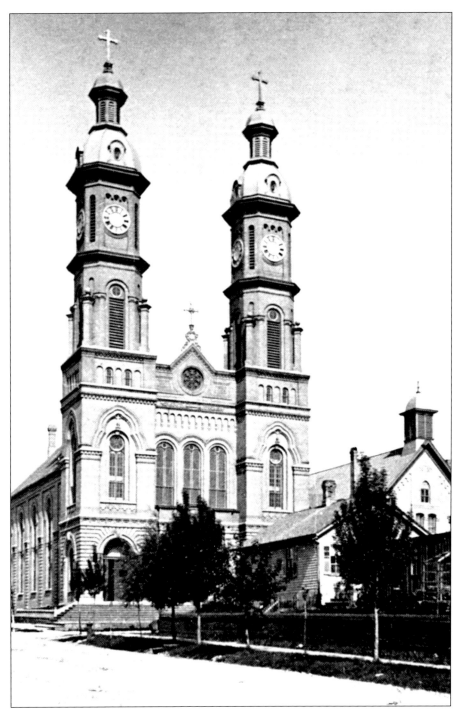

St. Stanislaus is located at South Fifth and West Mitchell Streets and was designed by Leonard Schmidtner. It is worth noting that the church's originally gold-plated domes were replaced with old copper-clad twin cupolas in the style of German Renaissance architecture. Also the entrances as well as parts of the interior have been completely remodeled. (Courtesy of the Milwaukee County Historical Society.)

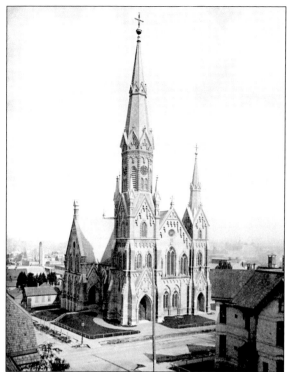

Trinity Lutheran Church is located at North Ninth Street and West Highland Avenue. It was designed by Fredrick Velguth. The church's tall and pointy towers make it one of the city's greatest examples of Victorian Gothic architecture. The fact that bricks were used as the main material, the way they were handled, and the shape of the tower make this church definitely German in origin. (Courtesy of the Milwaukee County Historical Society.)

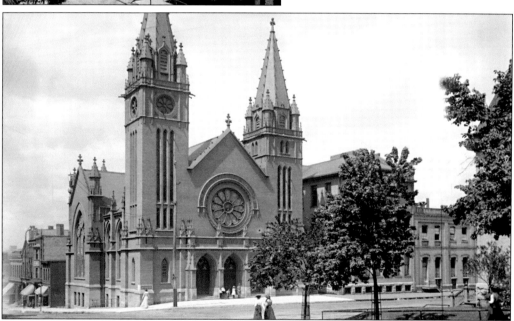

Grace Lutheran Church, originally named Muehlhauserkirche, is located at North Broadway and East Juneau Avenue. It was designed by Armand Koch, the son of Henry C. Koch. Over the entrance is a band of terra-cotta that reads, "1850 Evangelisch-Lutherische Gnaden Kirche 1900" (1850 Evangelical-Lutheran Church of Merci 1900). In the 1950s, the towers experienced deterioration and had to be taken down. They were rebuilt without their original terra-cotta features. (Courtesy of the Milwaukee County Historical Society.)

St. Stephen's Lutheran Church is located at South Fifth Street and was designed by Otto C. Uehling and George Griswold. The architecture is influenced heavily by the German Gothic style. It is the second-oldest Lutheran church in Milwaukee and one of the first steel-masonry structures built in the city. An already existing tower and steeple, constructed in 1879, was beautifully incorporated in the "new" building. (Courtesy of the Milwaukee County Historical Society.)

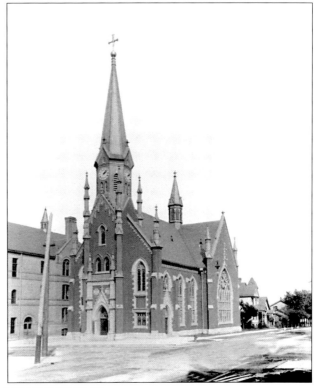

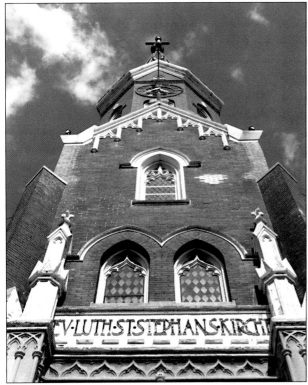

The German writing above the entrance reads, "Ev Luth St. Stephans Kirche" (Evangelical Lutheran St. Stephan Church). The history of the church strongly reflects the changes experienced in the community. It was once mainly attended by German immigrants, and hence, services were in German. This tradition continued up until World War I. Starting in 1922, both the German and English languages were utilized for each Sunday service. (Courtesy of the Milwaukee County Historical Society.)

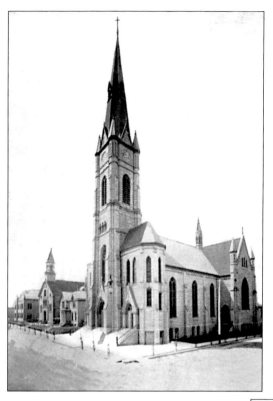

St. Michaels Roman Catholic Church, located on North Twenty-fourth and West Cherry Streets, was designed by Schnetzky and Liebert in 1892. Eugene R. Liebert was born in 1866 in Berlin and immigrated to Milwaukee. Liebert's first architectural drafting job was with Henry C. Koch. One of the partners in this company was Herman P. Schnetsky, who emigrated from Hamburg, Germany. Interestingly, Milwaukee limestone was used to build the church. (Courtesy of the Milwaukee County Historical Society.)

Koch started his own business in 1870. He adapted many popular styles and commissions for religious, residential, educational, industrial, commercial, and civic structures. He was also a member of the Western Association of Architects and a founder of the Wolcott Post of the Grand Army of the Republic. His work was very well recognized in other states as well as by the professional press. Interestingly, at Henry C. Koch's firm, German was the official language and German architecture was the official company design. (Courtesy of the Milwaukee County Historical Society.)

Roman Catholic Church of Gesu is located on West Wisconsin Avenue. The church is very Gothic in style and is reminiscent of the cathedral in Cologne. The building is separated into an upper and lower part, and each holds 1,450 people. The organ is considered one of the finest in America. The main altar in the upper church was designed by Alexander C. Eschweiler in 1927. (Courtesy of the Milwaukee County Historical Society.)

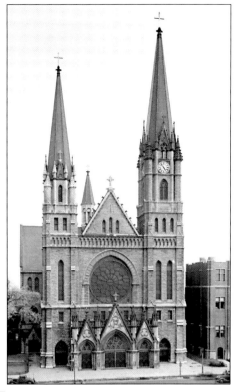

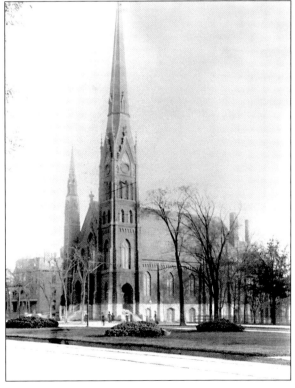

Calvary Presbyterian is located on the corner of North Twentieth Street and West Wisconsin Avenue. The west spire is several hundred feet high and supposedly caused anxiety in one of the elders. He claimed that it could easily be torn down. Henry C. Koch invited him to try it; ropes were rigged from the tower and horses were supposed to pull it down. The attempt failed; the tower would not move. (Courtesy of the Milwaukee County Historical Society.)

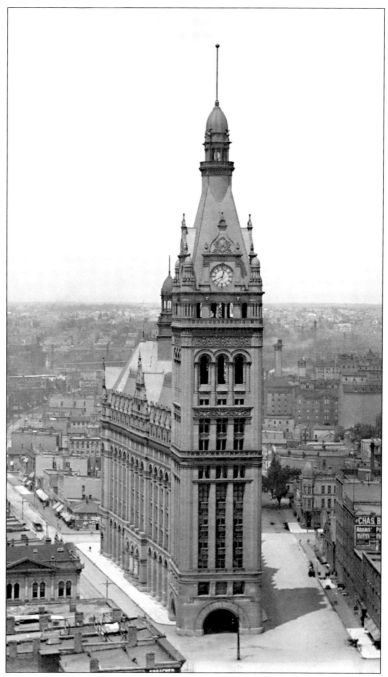

City hall, once one of the world's largest masonry structures, is located on East Wells Street. It resembles the "new Renaissance" style so popular in Germany at the time. The tower, in particular, reflects the architecture of the *Rathaus* (city hall) in Hamburg, Germany, and the decorative details of the buildings are reminiscent of the Friedrichsbau in the Heidelberg Castle in Germany. The bell, which was the third largest in the world when city hall was built, cannot be rung anymore because the vibrations weaken the structure. (Courtesy of the Milwaukee County Historical Society.)

The enormous tower of city hall rises 350 feet above the ground. A national competition was held in 1891 to select an architect who could design a building that was eight stories high, fireproof, of modern structure, and well suited for government use. A special committee decided that due to financial reasons, the original design by Henry C. Koch could not be selected. Once Koch made changes to his plan, though, his design was chosen. (Courtesy of the Milwaukee County Historical Society.)

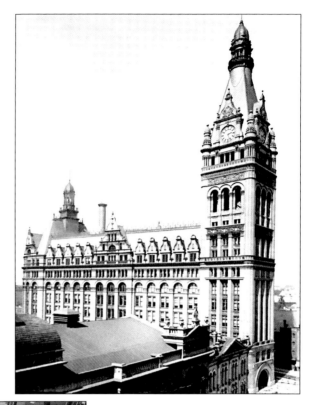

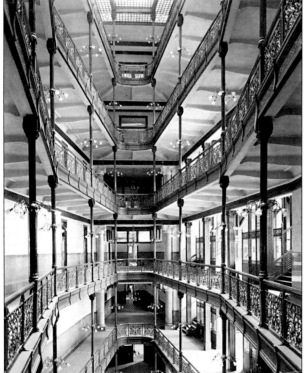

This picture shows the inside of city hall with its magnificent staircases. Many pieces, such as mosaic floors and marble bases, were added after construction started in 1893. This aggravated one alderman who claimed it would soon become a monument of expense rather than effectiveness. (Courtesy of the Milwaukee County Historical Society.)

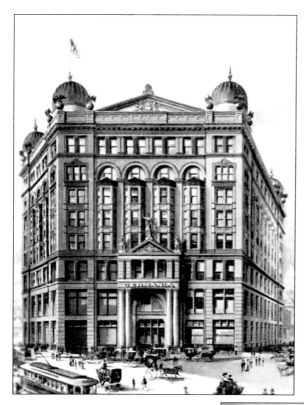

The Germania Building, designed by Herman P. Schnetzky and Eugene R. Liebert in 1896, truly marks the city's German heritage. It is located at 135 West Wells Street. The four domes have been called the "Kaiser's helmets." At one time this building housed the Germania Publishing Company, which was—at its height—the largest publisher of German-language materials in the United States. (Courtesy of the Milwaukee County Historical Society.)

Turner Hall is located on North Fourth Street, and it was called the Sozialer Turnverein (Social Gymnastics Club), built by Germans who combined the concept of healthy body and healthy mind. The ballroom and the roof were destroyed by a fire in 1934. The ballroom has recently been restored. The interior and exterior of the building have been altered substantially over time. (Courtesy of the Milwaukee County Historical Society.)

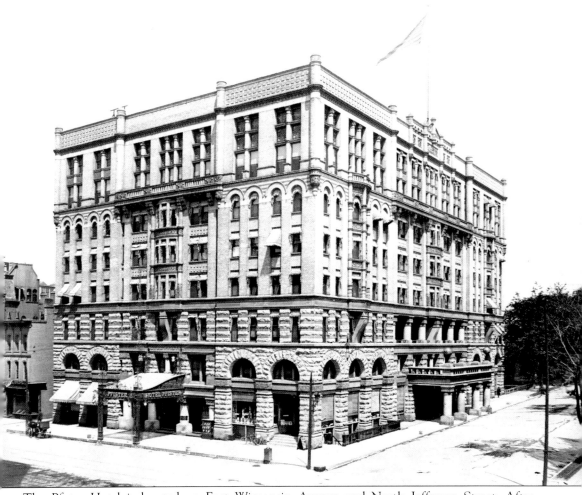

The Pfister Hotel is located on East Wisconsin Avenue and North Jefferson Street. After disastrous fires destroyed many buildings, Guido Pfister wanted to build a hotel that would be more fireproof and therefore safer. The first three stories of the building are constructed of Wauwatosa limestone, trimmed with Indiana limestone. The rest of the building is made of the famous cream pressed brick for which Milwaukee earned its nickname "Cream City." (Courtesy of the Milwaukee County Historical Society.)

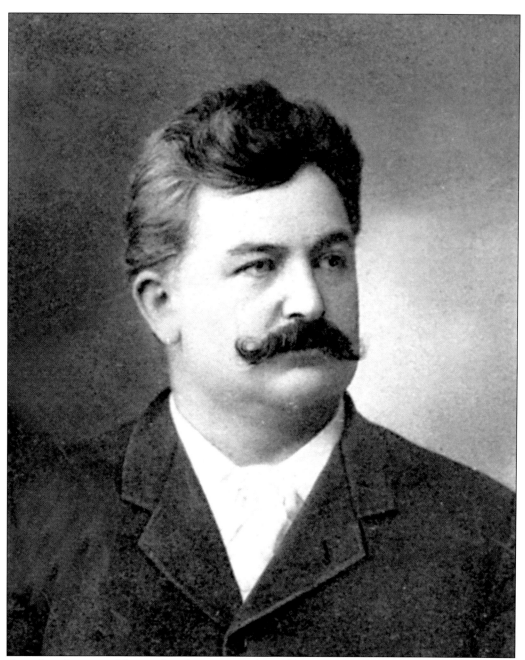

Otto Strack received his early education in the public schools of Germany. He learned the blacksmith and mason trades and also attended a building school. In addition, Strack studied architecture in Berlin and Vienna. In 1881, he immigrated to Chicago, and his good reputation helped him to find work. In 1886, he opened his own office from which he designed many buildings for the city of Chicago as well as Milwaukee. (Courtesy of the Milwaukee County Historical Society.)

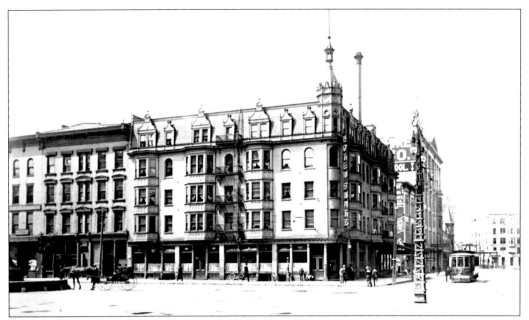

The Blatz Hotel was located at North Water Street and East Wells Street and was remodeled according to the plans of Otto Strack. Architecturally the hotel was clearly European in style: the turreted corner, the dormers, and bay windows were all reminiscent of some of the smaller 19th-century inns in Germany. The hotel dwindled in popularity and was left vacant until torn down in 1969. (Courtesy of the Milwaukee County Historical Society.)

Blatz Brewery was founded by the prominent Valentin Blatz in 1897. It was the first brewery in Milwaukee to begin the bottling process of beer. Architecturally the building resembles others with the Milwaukee common brick and Wauwatosa limestone walls. The office building of the brewery stands at 1120 North Broadway and is in sharp contrast to the other buildings. It was built in 1890 in the modified Romanesque style. (Courtesy of the Milwaukee County Historical Society.)

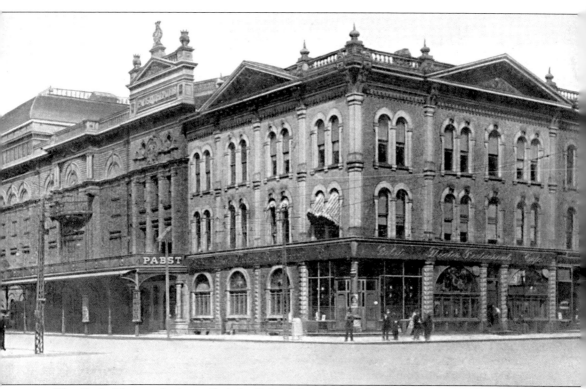

The Stadt Theater (today called the Pabst Theater) was located on East Wells Street. It was built for the public—Frederick Pabst wanted to offer the city an artistic venue. The original Stadt Theater was built in 1890 but was destroyed by fire in 1895. Pabst ordered the theater to be rebuilt immediately and hired Otto Strack, who created a theater reminiscent of the German Renaissance Revival style with apparent baroque influence. The building itself provides an acoustically excellent auditorium for performances. The architect employed gray sandstone, St. Louis brown pressed brick, and terra-cotta ornaments for the exterior. (Courtesy of the Milwaukee County Historical Society.)

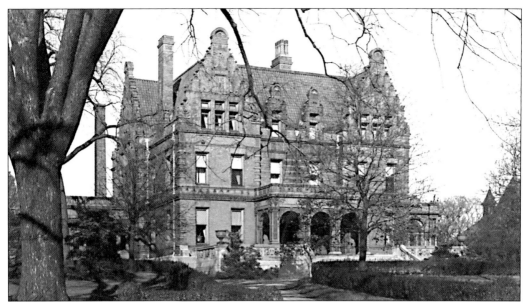

The Pabst mansion is located on Wisconsin Avenue next to the WISN 12 news channel headquarters. It was the residence of brewing company owner and entrepreneur Frederick Pabst. The mansion is considered one of the greatest works of the architect George Bowman Ferry. It was designed according to a three-story symmetrical plan and included tan pressed brick with carved stone and terra-cotta trim work. It is the only one of its kind in the Midwest. (Courtesy of the Milwaukee County Historical Society.)

At the ladies parlor, women would get together, talk, play cards, or engage in "other female activities." Rococo is the predominant style in this room, with furniture designed to match it. It is worth noting that this picture was clearly taken at Christmastime and that the room is decorated according to German tradition. (Courtesy of the Milwaukee County Historical Society.)

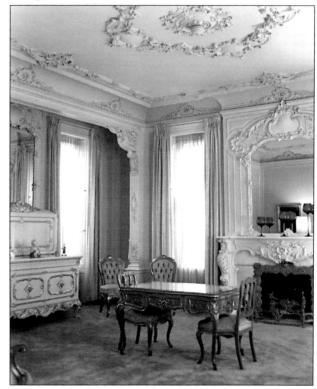

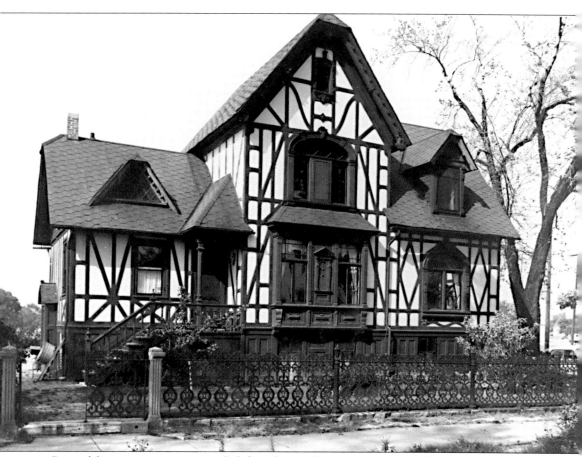

Beautiful in its appearance and definitely standing out in its neighborhood is the Machek residence. The house is located on North Nineteenth Street. It was built by Robert Machek, who was a well-known woodcarver, carpenter, and cabinetmaker from Vienna, Austria. This home shows direct German influence with its wooden frame and simulated half-timber construction. (Courtesy of the Milwaukee County Historical Society.)

Besides designing the Stadt Theater and the Blatz Hotel, German architect Otto Strack also created private homes. The Kalvelage mansion beautifully demonstrates the architect's love for baroque architecture with its fantasy of carvings and figures. Today this building is located on West Kilbourn Avenue. Joseph Kalvelage dreamt of having a street full of magnificent mansions. He called this residence Schloss (castle). It has a symmetrical structure, which makes it seem like a fortress. Tan pressed brick was used to build the home. The outside was decorated with terra-cotta ornamentation such as crowned and winged heads and lions with shields. The main entrance porch on the south side of the house is the most stunning part of the building. It is supported by eight full-figured telamones. The detailed interior also shows, just like the outside, many baroque features. (Courtesy of Zlatko Sadikovic.)

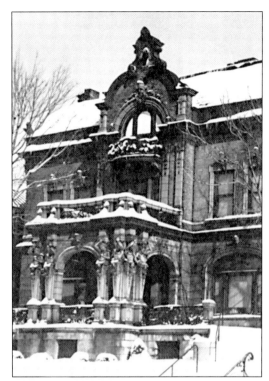

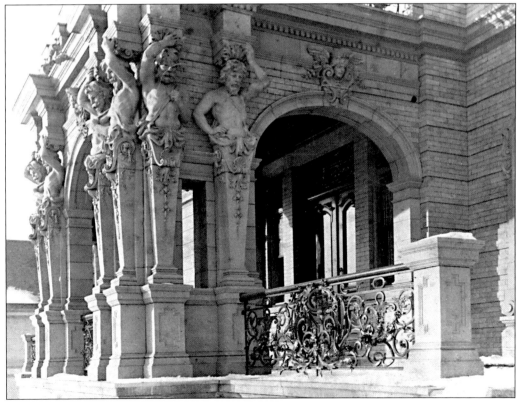

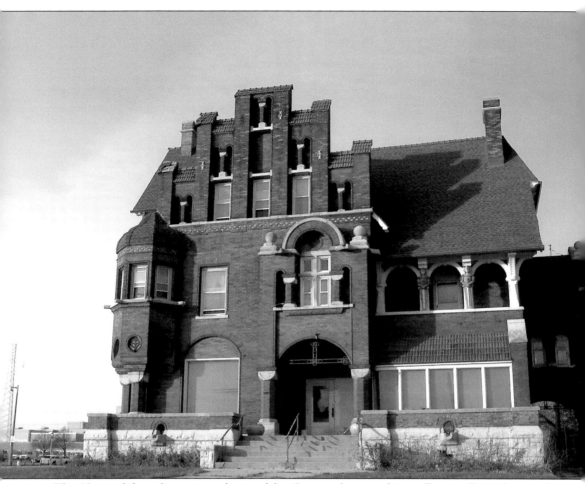

The Harnischfeger house was designed by German-born architect Eugene R. Liebert and is located on West Wisconsin Avenue. A "modern" German style, defined by its usage of traditional architectural forms in an abstract way, was used to create this building. A unique feature of the home is the second-story porch with its columns in the form of knights in armor. (Courtesy of Zlatko Sadikovic.)

Two

RELIGION AND EDUCATION

Many German immigrants came to Milwaukee in search of better religion and educational circumstances.

The first group of Germans to come to Milwaukee was the "Old Lutherans." They were followed by the German Catholics and Jews, a number of smaller denominations, and freethinkers. Despite differing religious viewpoints and mutual mistrust, the one issue that united Germans along national lines was their appreciation of the role language played in faith and culture. Both Catholics and Lutherans built parochial schools for their children, seeking to preserve their German language, traditions, and respective faiths. To this end, the area's largest Catholic teaching house was founded in 1849 by the School Sisters of Notre Dame, and both Lutheran synods had founded training schools for teachers as early as 1854. A steady influx of Christian German immigrants and a value for religious education kept these schools healthy for decades.

German was widespread as the language of instruction in the 1850s. Six private German English schools taught more than 1,000 students, and parochial schools taught more than 3,000. By 1899, 73 percent of Milwaukee public school students were enrolled in 700 German courses, and some schools had German entries in their monthly publications.

Wisconsin's 1889 Bennett Law threatened bilingual education in Wisconsin schools. All students would have to attend schools within their own districts, regardless of whether the schools were public, private, or parochial. And all instruction would have to be in English. German Catholics and Lutherans united to depose the law, and the Bennett Law was repealed within the year.

World War I brought the end of German instruction in the Milwaukee public schools, partly because Germans had largely integrated by this time and partly because of World War I anti-German sentiment. In 1916, the Milwaukee public schools had 200 German teachers teaching 30,000 students; in 1918, Milwaukee public schools had 1 German teacher teaching 400 students; by 1919, German was no longer taught.

Bilingual education continues today at the Milwaukee German Immersion School and the Milwaukee School of Languages, testimony to the German immigrants who left their mark on the educational development of the city.

—Anne Birsching, Kelly Popko, and Anne Schumacher

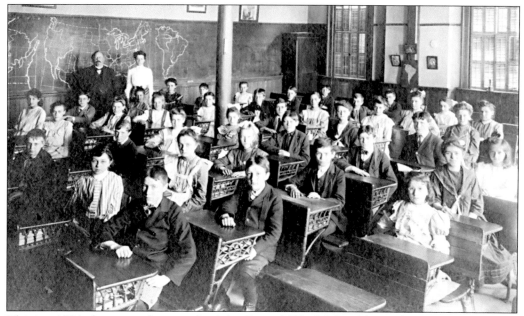

This is a 1904 classroom photograph of the Second Ward School located at Tenth and Prairie Streets (present-day Highland Street). In the background is principal Dietrich C. Luening, a contemporary of Peter Engelmann. The Second Ward School was located in a predominately German neighborhood where German instruction was received up to three hours per week. (Courtesy of the Milwaukee County Historical Society.)

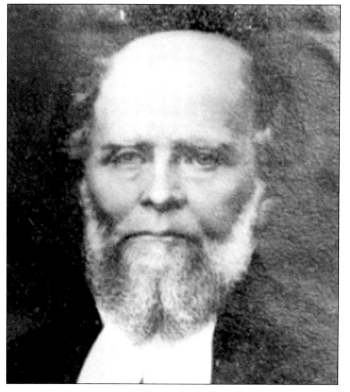

Heinrich von Rohr was a captain in the Prussian military. When the kaiser demanded that the Lutherans join the United Reform Church, von Rohr, being Lutheran, refused. He was released from the military for insubordination. He joined the "Old Lutherans" and handled the details of physically moving the first group of Lutherans to Wisconsin in 1839. He served as the temporary church leader until they received their first pastor. (Courtesy of Concordia Historical Institute of the Lutheran Church–Missouri Synod.)

Trinity Evangelical Lutheran Church in Freistadt (right) and Milwaukee (below) was the first German church established in the Milwaukee area in 1839. Not long afterward, this church and several others split because of differing opinions. Trinity in Milwaukee joined the Missouri Synod when it was established in 1847 and built a new church and school in 1851. The school also housed the forerunner of Concordia College. The Buffalo Lutheran Synod was officially organized in 1845 at Trinity in Freistadt. This congregation remained a member of the Buffalo Synod until it joined the Missouri Synod in 1848. The congregation celebrated its 160th anniversary in 1999. (Courtesy of the Milwaukee County Historical Society.)

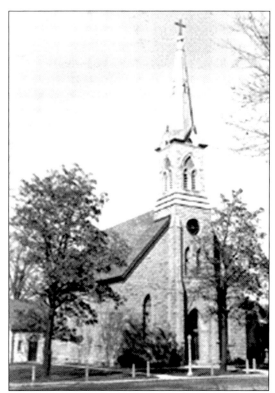

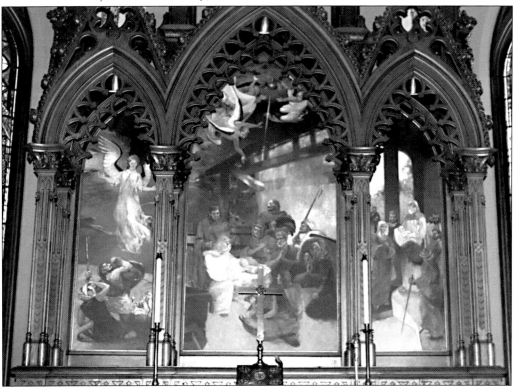

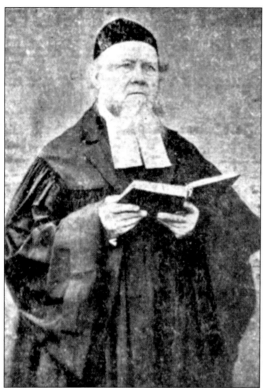

Rev. E. F. L. Krause became the first pastor of Trinity Church in Freistadt in 1841. Krause was a controversial figure in the early Lutheran churches in Milwaukee. He particularly displayed this when he excommunicated the entire congregation of the Milwaukee half of Trinity because they would not pay him more money. Eventually the congregation split, and he and part of the congregation joined the Buffalo Synod. (Courtesy of Concordia Historical Institute of the Lutheran Church–Missouri Synod.)

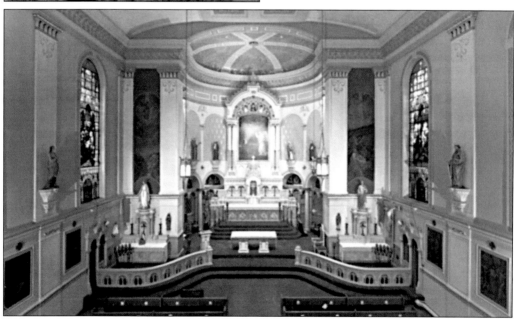

Old St. Mary's, founded in 1846 and located at 836 North Broadway, was the Roman Catholic sister church of St. Peters. The *Frauenverein* (women's club), a German-speaking women's organization within St. Peters, had aspired for such a church, and their work was instrumental in the church's founding. The cornerstone to Old St. Mary's was laid by Bishop John Martin Henni on April 19 of that year. (Courtesy of the Milwaukee County Historical Society.)

John Martin Henni was Milwaukee's very first bishop and later archbishop. He was largely responsible for the development of Milwaukee's Roman Catholic infrastructure—parishes, schools, seminaries, and so on. Born in Switzerland, Henni encouraged the use of the German language in both parish life and education—a policy that would become greatly controversial by the dawn of the 20th century. He was the first of four consecutive German-speaking archbishops in Milwaukee. (Courtesy of the Milwaukee County Historical Society.)

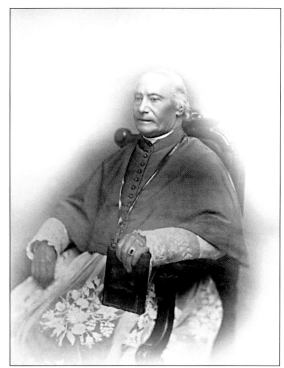

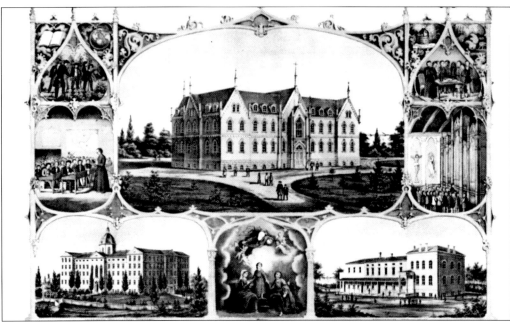

St. Francis Seminary (lower left picture) was founded in 1845 by Bishop Henni to educate future priests and to serve Milwaukee's bourgeoning Roman Catholic population. To this end, Henni brought 50 Jesuit priests and 90 seminary students back from a visit to Rome in 1849. Interestingly, this influx of Catholic clergy coincided with a wave of anticlergyism throughout Milwaukee's freethinking population, as well as some of its Lutheran population. (Courtesy of the Wisconsin Historical Society.)

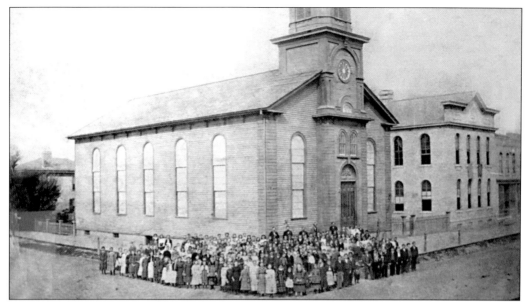

St. John's Lutheran was dedicated in 1850 as St. Johannis Kirche. The pastor, Henry Ludwig Dulitz, belonged to the Missouri Synod, but the congregation itself was never accepted into the synod. He was asked to resign, and Pastor Wilhelm Streiszguth, a Swiss Reformed minister, was called to the congregation. He helped it join the Wisconsin Synod. St. John's, now located at Eighth and Vliet Streets, is once again an independent Lutheran Church. (Courtesy of the Milwaukee County Historical Society.)

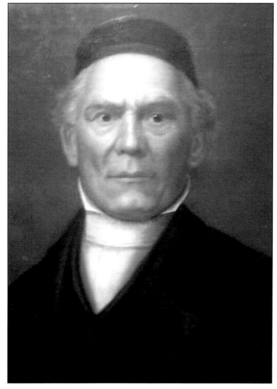

Rev. John Muehlhaeuser was a missionary trained and sent to America by the Langenberg Society in Germany, which was devoted to missionary work in the New World. Muehlhaeuser arrived in Milwaukee in 1848 and founded Grace Lutheran Church in 1850. Two of his fellow missionaries, who shared the same beliefs as him, joined him to form the Wisconsin Lutheran Synod. Muehlhaeuser became the first president of the synod. (Courtesy of the Wisconsin Evangelical Lutheran Synod Historical Institute.)

The first permanent kindergarten building was located in Watertown. The school was in operation for two years (1856–1858) by Margarethe Meyer Schurz. In 1858, she returned to Germany, but the kindergarten movement continued in her absence for over 40 years. Singing and playing were all conducted in German. Children learned to observe nature as well as how to play well with others. (Courtesy of the Wisconsin Historical Society.)

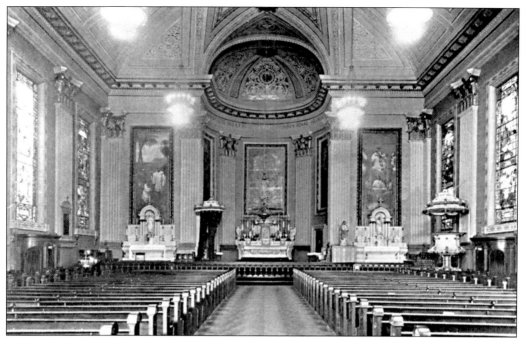

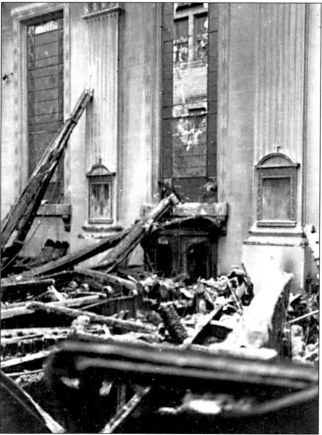

Construction of the Cathedral of St. John the Evangelist in Milwaukee began on December 5, 1847, by Bishop John Martin Henni and was completed in 1853. It was Wisconsin's first cathedral. Over the years, it underwent various renovations, such as the adding of a pipe organ and a clock tower, revisions on the clock tower, and so on. The cathedral was almost totally destroyed on January 29, 1935, when fire struck, leaving only parts of the north and south walls. The cathedral's reconstruction began that same year, and upon reconstruction, the building was wired for electricity, a new pipe organ was added, and the timing of the bells was converted to an automatic timer. This cathedral continues to be the mother church of its diocese. (Courtesy of the Milwaukee County Historical Society.)

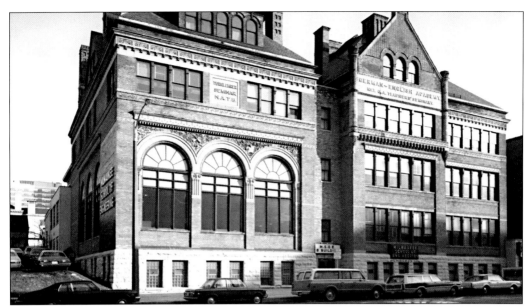

The German English Academy was established in 1851 by the Deutsch-Amerikanische Lehrerverein (German American Teacher Society). Pictured is its final facility located on the west side of Broadway between Juneau Avenue and Knapp Street. The building also housed the Turn-Lehrer (Gymnastic Teachers) Seminary and the National German Teachers Seminary (1890–1919). The Milwaukee School of Engineering took over the building in 1932. (Courtesy of the Milwaukee County Historical Society.)

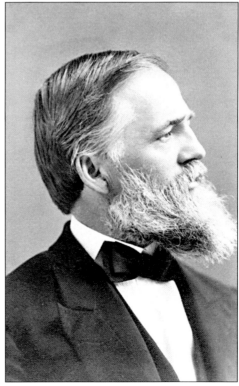

Peter Engelmann, first teacher and later principal of the German English Academy, was an exiled 48er from Germany. He believed in a well-rounded, bilingual education with a curriculum that included gymnastics, manual training, and natural history. The founder of the natural history museum opened the school's collections for viewing by the public schools. (Courtesy of the Milwaukee County Historical Society.)

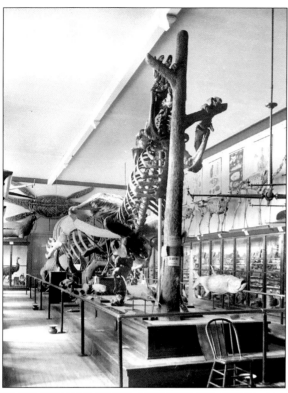

Out of Peter Engelmann's love for natural sciences grew a collection of over 23,000 artifacts. A museum was first established within the German English Academy. This collection grew into what is now the Milwaukee Public Museum. Pictured is an exhibit of a prehistoric animal once located in the museum. The first curator was Carl Doerflinger, a Civil War veteran and former student of Engelmann. (Courtesy of the Wisconsin Historical Society.)

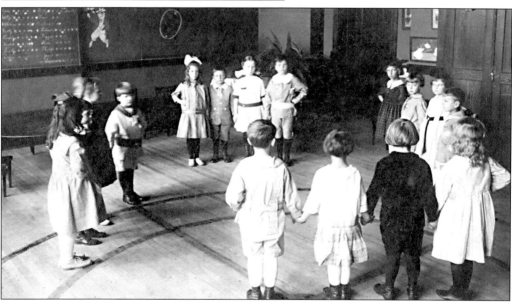

Kindergarten was introduced at the German English Academy in 1872. Even though this was a German kindergarten, it incorporated parts of the Montessori technique. This technique allowed the children to choose their own activities rather than work in teacher-led organized groups. This would help the children develop creativity and independence of thought and action in order to contribute to society and the environment. (Courtesy of the Milwaukee County Historical Society.)

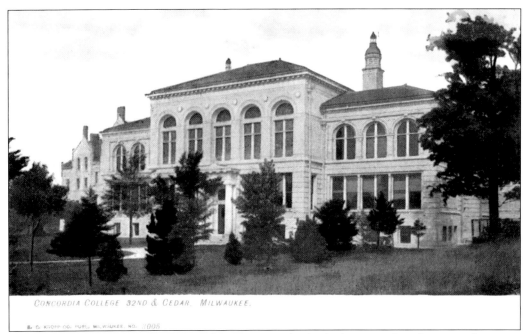

Concordia College opened on September 1, 1881, with 13 scholars attending. Its original purpose was a preseminary for young men. The curriculum grew in breadth to include majors such as the health professions, foreign languages, and business. The current location celebrated its 25th year in Mequon in 2008. The property previously was the motherhouse of the School Sisters of Notre Dame. (Courtesy of the Wisconsin Historical Society.)

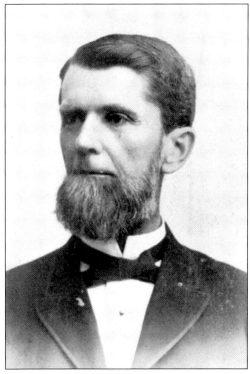

When the enrollment at Concordia College reached 149 pupils in 1885, the full-time position of president was established. Rev. Christoph H. Loeber served as Concordia's first president from 1885 to 1893. During his terms, enrollment increased and Concordia College achieved the status of junior college in 1890. Loeber supplied the institution with stability, which led to its early success. (Courtesy of the Concordia University Archives.)

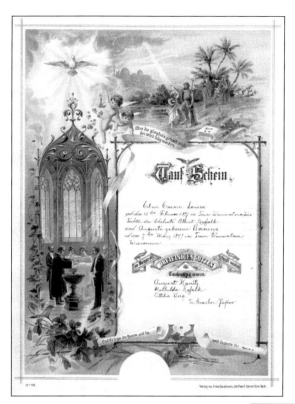

These are the baptism and confirmation certificates of Edna Emma Louisa Kufalk, who was a member of Apostle's Lutheran Church in Wauwatosa. As typical with Lutheran children, she was baptized shortly after her birth in 1897 and was confirmed at the age of 14 in 1911. Children received intensive instructions on Martin Luther's small catechism in the last two years of grade school. Before graduation, they were examined and then confirmed as full members of the congregation. Lutheran Churches continued to use German in all church matters, and in instructing their children, as is evidenced in the German used in the certificates. (Courtesy of Jeff Geil.)

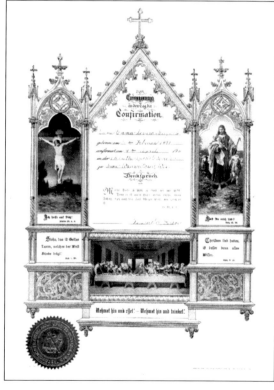

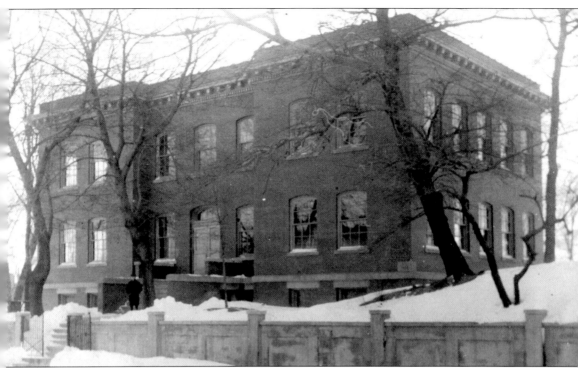

The Lutheran community founded Lutheran High School in 1903, and this was its first permanent location on Thirteenth and Reservoir Streets in 1908. German was used for most of the instruction at this new school until the war era. In 1961, when the Wisconsin and Missouri Synods parted ways, the name of the school was changed to Wisconsin Lutheran High School, and it is still in operation today. (Courtesy of the Wisconsin Lutheran High School Archives.)

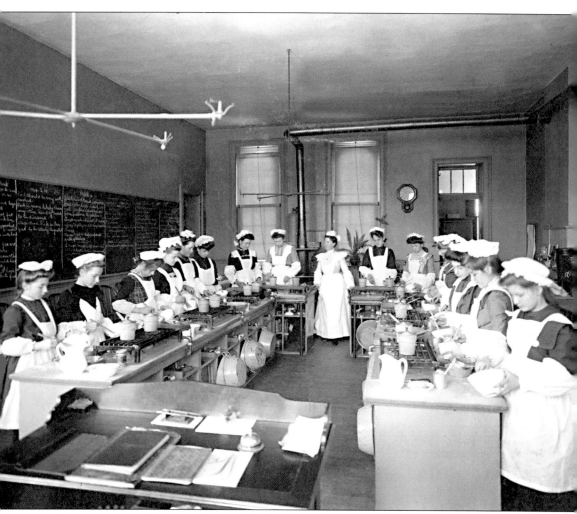
This is a cooking class at the Second Ward secondary school at the beginning of the 20th century. Cooking and domestic training for girls and young women were German concepts introduced by German educators at German English schools and deemed essential to German immigrants. This is one example of the German influence on Milwaukee public schools. (Courtesy of the Milwaukee County Historical Society.)

This photograph of girls was taken at the School Sisters of Notre Dame convent, near the dawn of the 20th century. Milwaukee's first motherhouse had been located on the grounds of Old St. Mary's Catholic Church. The School Sisters of Notre Dame was a vital force in training female teachers, founding kindergartens, providing care to orphans, and developing Catholic Milwaukee's parochial schools. They were important in Milwaukee, but their work was also global. Motherhouses were founded not only all over the United States and Canada but also throughout Europe, Latin America, Africa, and Asia. (Courtesy of the Milwaukee County Historical Society.)

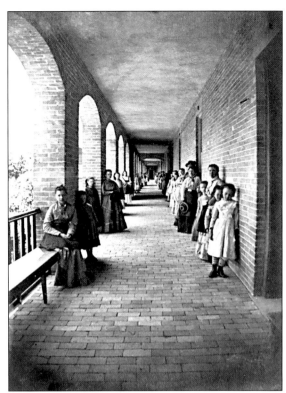

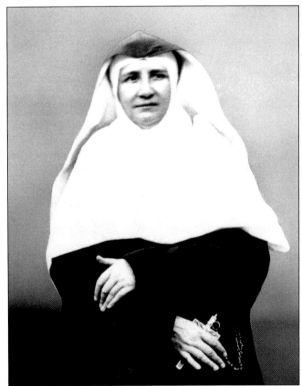

The School Sisters of Notre Dame was founded in 1833 by Mother Theresa of Jesus Gerhardinger, and its Milwaukee motherhouse was founded in 1850 by Mother Caroline Friess. That same year, at only 26 years of age, Mother Caroline Friess was appointed vicar of North America. (Courtesy of the School Sisters of Notre Dame Convent.)

In 1906, children at the German-speaking Catholic parish of St. Bonifacius celebrated their first communion. Along with baptism, confirmation, penance, marriage, and Christian burial, communion—or Eucharist—is an important Catholic sacrament. It is perhaps the most sacred, because as a memorial of Christ's death and resurrection, it is believed to contain Christ himself, therefore serving as the source of the church's spiritual nourishment and growth. (Courtesy of the Milwaukee County Historical Society.)

This 1919 class photograph is of students of the German English Academy. By this time German was merely an academic option. Due to the negative German sentiment during World War I, the school changed its name in 1918 to Milwaukee University School. The institution provided an outstanding private education from kindergarten through 12th grade, but without the strict bilingual philosophy envisioned by the school's founders. (Courtesy of the Milwaukee County Historical Society.)

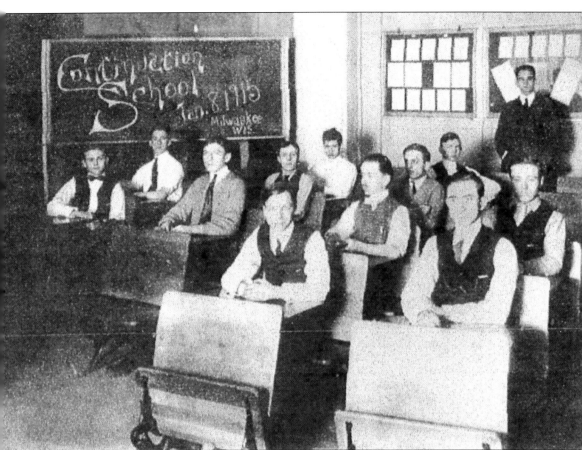

As an outgrowth of German insistence on manual training for its youth, vocational schools began opening in 1912. Social reformer Charles McCarthy's passion for Milwaukee's young people began the Continuation School in rented quarters in the manufactures' home building (Mason Street) and at the Stroh Building. The school grew rapidly and evolved with the changing demands of each decade. Later this grew into Milwaukee Area Technical College (MATC) in 1923. (Courtesy of the Milwaukee County Historical Society.)

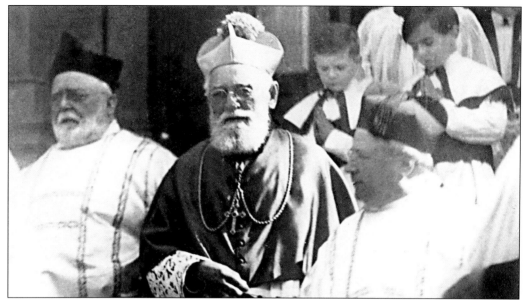

Archbishop Sebastian Messmer, Messmer High School's namesake, is Milwaukee's fourth German-speaking archbishop, shown here at the golden jubilee celebration on October 4, 1921. Messmer did not continue the push for the German language to be used in mass as his predecessors had because by this point Milwaukee Germans themselves had so integrated into the main population that German language instruction became a moot point. (Courtesy of the Milwaukee County Historical Society.)

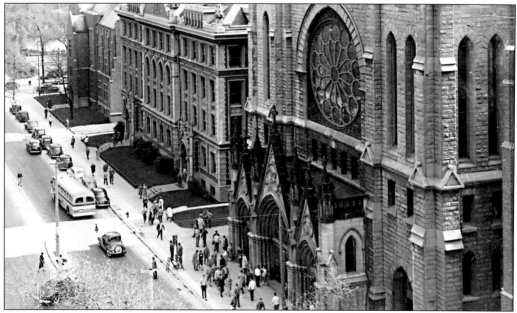

The Jesuit Marquette University, photographed here in the 1930s, opened on August 28, 1881. Such an institution of higher learning had been the dream of Bishop John Martin Henni, and its first class of five graduated in 1887, earning bachelor of arts degrees. As of 2007, more than 11,000 students were enrolled as either undergraduate or graduate students. (Courtesy of the Milwaukee County Historical Society.)

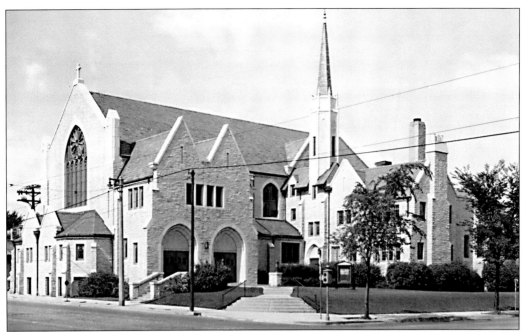

Sherman Park Lutheran (Missouri Synod), located near the corner of North Sherman Boulevard and West Center Street, was approved on January 21, 1923, as the two congregations of Hope Lutheran (Missouri Synod), located at Thirty-fifth and Cherry Streets, and Mount Lebanon Lutheran Church (Wisconsin Synod) merged. Both German congregations had been founded in the early 1900s. Today Sherman Park Lutheran annually holds German services at Christmastime. (Courtesy of the Milwaukee County Historical Society.)

Pastor Don Hougard of Benediction Lutheran Church (Missouri Synod) held the first German service on Good Friday in 1997. Since then he has been assisted by Pastor Eberhard Klatt of Bethany Lutheran and John Goldman. German services are offered monthly. Pastor Klatt can also be heard on the radio at WJYI 1340 AM broadcasting *Evangelische Andacht* (Evangelical Prayers). Approximately 1,200 listeners tune in each Saturday afternoon. (Courtesy of Anne Schumacher.)

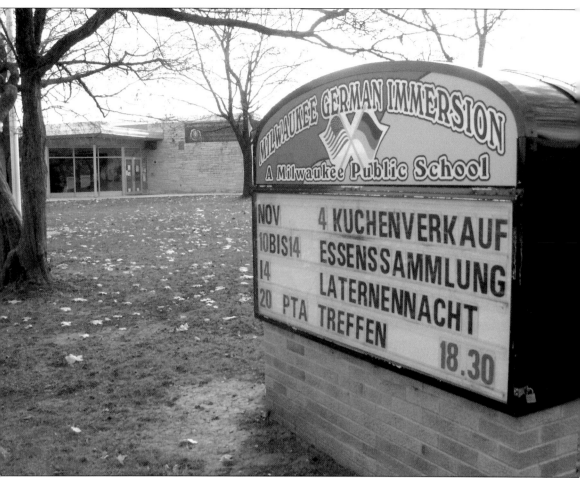

The Milwaukee German Immersion School—a Milwaukee public school—opened its doors in 1977. It is a kindergarten-through-fifth-grade bilingual school, using both English and German in the classroom. The school has received many awards for academic excellence. It is a citywide school enrolling children from throughout Milwaukee. The school is racially balanced with students from many ethnic and cultural backgrounds. (Courtesy of the Milwaukee German Immersion School.)

Three

THE POLITICS OF GERMAN MILWAUKEE

Germans who immigrated to Milwaukee in the 19th century found themselves spread out along the political spectrum.

In the early 19th century they chose between the Democratic Party and the Whigs. The Whig Party was not an option because they opposed granting franchise to immigrants and also favored temperance, so many aligned themselves with the Democratic Party. In 1854, many German immigrants in Milwaukee began to align with the new Republican Party, owing to its antislavery platform. After the Civil War, the more conservative and religious Germans began to vote Democrat once again, while those more liberal remained Republican.

Milwaukee's German Americans, who counted many skilled workers among them, united around the need for labor unions. The first evidence of union action appeared in 1847 when 40 masons and bricklayers went on strike for a wage increase from $1.50 to $1.75 a day. The action was unsuccessful, yet the groundwork was set; and by 1867, there were 16 local labor unions in Milwaukee. The idea of unions was of particular interest to such a political group as the socialists. German laborers were well aware that they were being discriminated against. In print offices, for example, German workers made approximately 30 percent less than their American, English-speaking counterparts.

The socialist movement in Milwaukee was a prominent one and played a greater role in Milwaukee than perhaps any other city in the United States. Milwaukee socialists did not focus too deeply on all the facets of Marxist ideologies. The "Sewer Socialists" as they became known, were more concerned with cleaning up the city of Milwaukee and forming a "good honest government." This is in fact how they got the name Sewer Socialists, which they embraced. As time went on, meetings were held in both German and English, and the movement led to the election of several socialist mayors in Milwaukee throughout the first half of the 20th century.

The many strides taken in workers' rights, child labor, shorter workdays, the department of public works, and the park system for which Milwaukee is well known are all thanks to German American politicians.

—Derek Schaefer

Milwaukee German Americans were so active in the laws and politics of the city that even the city ordinances were printed in German. Here the ordinances of 1914 have been printed in the *Germania-Herold*, a German American Milwaukee paper. (Courtesy of the City of Milwaukee Legislative Reference Bureau.)

Eugene V. Debs (left) and Victor Berger (right) were considered the founders of the socialist movement in the United States and Milwaukee. Berger was born in Austria-Hungary on February 28, 1860, and moved to Milwaukee in 1881. At the time he did not speak English, but Milwaukee was a German city that published five German daily newspapers. Debs, originally of Terre Haute, Indiana, was converted to socialism by Berger while in jail in Illinois in 1895. (Courtesy of the Milwaukee County Historical Society.)

This is the site where *Wisconsin Vorwaerts* was first printed at 614 State Street. Victor Berger quit his job as a teacher and became editor of the *Arbeiter Zeitung* in 1893. He later changed the name to the *Wisconsin Daily Vorwaerts* (Forward). Berger used it as a platform to denounce social injustices and put forth socialist ideas for change. The *Vorwaerts* stayed in print until 1932. (Courtesy of the Milwaukee County Historical Society.)

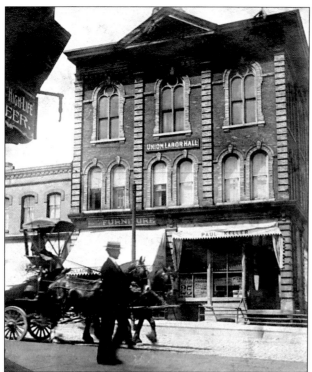

Union Labor Hall on the corner of Sixth Street and Juneau Avenue is where the Milwaukee Federated Trades Council met in the early days. The council was formed through the unification of local unions in 1887. The Federated Trades Council supported and endorsed the socialists and Social Democratic Party. In true socialist fashion, after 1893, the trades council never had a president. Rather, a chairman was elected at each meeting. (Courtesy of the Milwaukee County Historical Society.)

Frederic Heath (right) was a news artist by trade but fell victim to technology. His job of creating print drawings for newspapers was replaced by a news photographer. Heath was an alderman in Milwaukee and took part in numerous social initiatives throughout his career, working closely with Victor Berger (left), Eugene V. Debs, and other socialists. He became editor of the *Social Democratic Herald* and introduced resolution in the socialists' fight against tuberculosis. (Courtesy of the Milwaukee County Historical Society.)

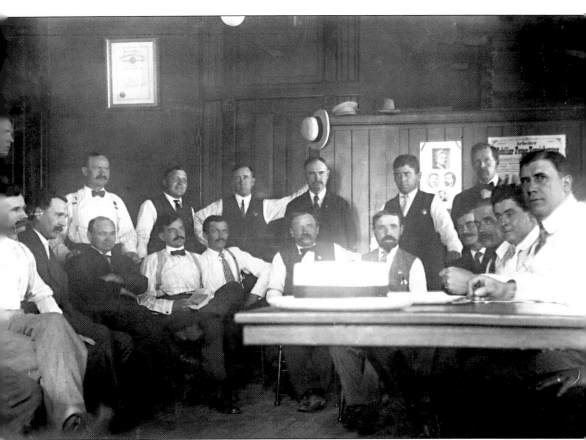

This early photograph shows members of the Social Democratic Party at a meeting. In the middle, seated, is Victor Berger. Two seats to the left is Daniel W. Hoan, who was the mayor of Milwaukee from 1916 to 1940. In the background to the right is a poster written in German. Many of the socialist gatherings were conducted in German, and halls were rented for both German- and English-speaking socialists. The Milwaukee socialist era reached its peak in 1912, when membership surpassed 125,000. Although socialist mayors were in power from 1910 to 1912, 1916 to 1940, and again from 1948 to 1960, membership steadily declined. Victor Berger claimed as early as 1921 that the socialists began to alienate other progressive movements and that the Social Democratic Party (as it was renamed in 1916) would not support any candidate or accept endorsement from anyone other than a "regular card holding member." And the number of German members began to decline as they found more ways to integrate into the American population. (Courtesy of the Milwaukee County Historical Society.)

Prominent Milwaukee socialists, from left to right, are Frederic Heath, Victor Berger, Eugene V. Debs, and Seymour Stedman (of Chicago), who called into action the forming of "the Social Democracy of America" in June 1897. They held a convention in Chicago and brought together the group from the remnants of the American Railway Union and other independent socialists. (Courtesy of the Milwaukee County Historical Society.)

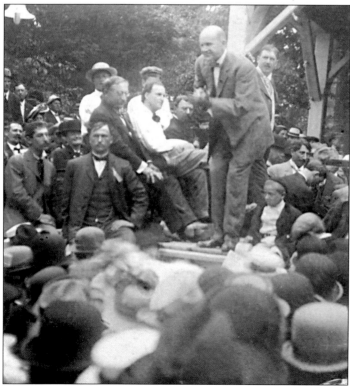

Eugene V. Debs ran as the socialist candidate for president four times between 1900 and 1912. The socialist trend, and hence, Debs's votes, increased every year, and he more than doubled his votes between 1908 and 1912. (Courtesy of the Wisconsin Historical Society.)

Emil Seidel was the first elected socialist mayor of any major American city and was nicknamed the "Good German Mayor." Victor Berger was elected to the House of Representatives in the fifth district, also a first for the socialists. The regime of David S. Rose, with its loose regulation of prostitution and open gambling, paved the way for the socialists. It was not easy to defeat the free and easy lifestyle that Rose brought to Milwaukee, but the socialists took life seriously. (Courtesy of the Milwaukee County Historical Society.)

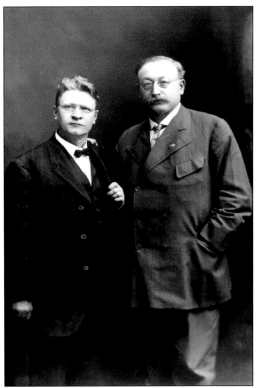

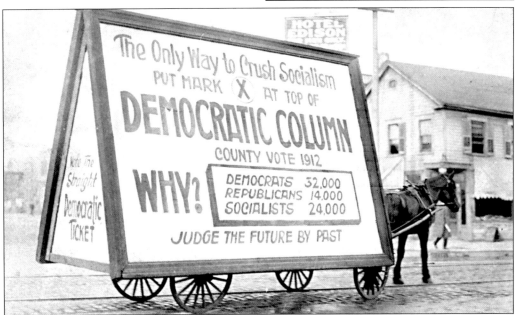

This sign shows the Democrats' 1912 attempt to take action against the socialists in order to win back the city. The sign insinuates that the work the socialists had done in the past was bad. However, the socialists ran the popular platform of municipal ownership of public utilities, employment of union labor, eight-hour workdays on city work, public work for the unemployed, and free medical and legal services for the needy. (Courtesy of the Milwaukee County Historical Society.)

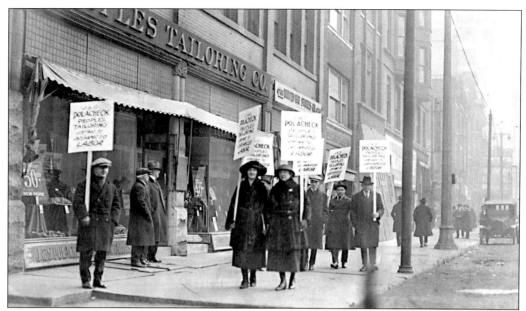

A popular tool of labor unions in Milwaukee was to strike in order to have demands met. Many different unions such as the tailors, bricklayers, brewers, masons, and railroad workers struck and used the influence of groups. Such groups included the Social Democratic Party itself as well as the Milwaukee Federal Trades Council. (Above, courtesy of the Milwaukee County Historical Society; below, courtesy of the Wisconsin Historical Society.)

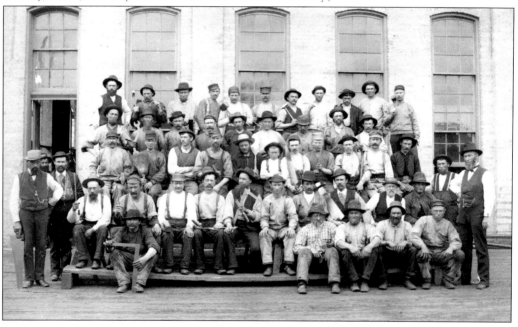

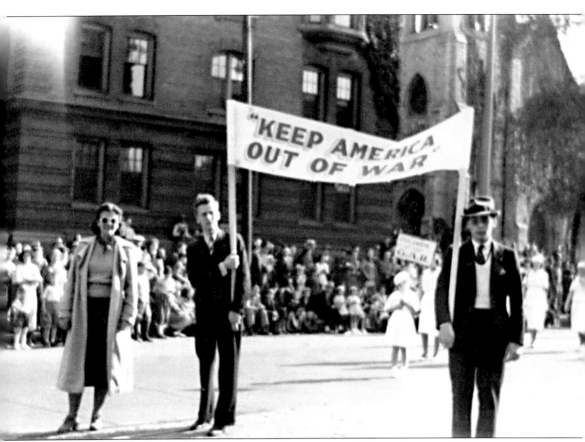

Germans in Milwaukee, and socialists in general, were overwhelmingly against U.S. entry into the world wars. They were pacifists and had sentimental ties to their homeland. Many may have remembered or heard stories of war-torn Europe during the 19th century. Emil Seidel, after his term as mayor, gave speeches denouncing U.S. entry into World War I. After the war was over, Victor Berger was quoted as saying, "You got nothing out of the War except the flu and prohibition." They disagreed with fighting over arbitrary lines drawn on a map for the profit and influence of the rich and politicians. (Courtesy of the Milwaukee County Historical Society.)

Brisbane Hall, which was located at 534 West Juneau Avenue, served as the Socialist Party headquarters. It was also where another one of Victor Berger's socialist publications, the *Milwaukee Leader*, was distributed. This paper came under fire from the *Milwaukee Journal* in 1917 for "encouraging disloyalty [to the United States]" during the war. Brisbane Hall was torn down in 1965 to make room for a highway. (Courtesy of the Milwaukee County Historical Society.)

Dan Hoan (right) had the longest tenure of any other socialist mayor in office. He spent his time from 1916 to 1940 fighting the streetcar companies that took unsatisfactory care of their systems. He also consistently saved the City of Milwaukee money in areas of public works. Unlike his fellow socialists, he did not openly oppose the United States' entry into World War I. Hoan solidified Milwaukee's image of honest and efficient politics. (Courtesy of the Milwaukee County Historical Society.)

The end of an era? Carl Zeidler (right) defeated Dan Hoan (left) in 1940 on the promise of "A new day for Milwaukee." The "singing mayor" (as he was called) was a conservative who appealed to the younger generation, promising that he would bring jobs and new industries to the city. It marked the end of the dominance of the Socialist and Social Democratic Party in the office of mayor. Carl Zeidler, who was of German descent, enlisted in the navy, and in December 1942, his ship was sunk by a German U-boat attack. (Courtesy of the Milwaukee County Historical Society.)

Frank Zeidler, brother of Carl, was elected mayor of Milwaukee in 1948 and served until 1960. He went on to improve the park system in Milwaukee as well as obtained funding for a highway system. Under his administration, the population of Milwaukee doubled and peaked in the 1960 census, and the economy was booming. Poverty and crime were also low while he was mayor. He always claimed to be a citizen who performed his civic duty and not a politician attempting to win a popularity contest. His policies, however, were highly contested as alderman in the city, and his vetoes were often overridden. He chose not to run for reelection in 1960. He was the Socialist Party's nominee for president in 1976. (Courtesy of the Milwaukee County Historical Society.)

Four

Industry and Business

German immigrants were involved in many professions in Milwaukee, employed both by small contractors and by giant corporations, and represented on all levels of the corporate ladder.

Milwaukee's nickname of "Brew City" stands as testament to the fact that the brewing industry and its liquid golden product have nestled themselves into the hearts and stomachs of Milwaukee's residents for over 150 years. It is largely believed that the German American who founded the first brewery was Hermann Reuthlisberger, establishing his business in 1841. Following Reuthlisberger's example, numerous German breweries sprouted up around the budding settlement. These brewers defined Milwaukee's beer industry for future generations as the work of German hands in a new and wild world.

With such a large number of animals on the land in Wisconsin, tanning also became a dominant profession in the area. Milwaukee tanneries were already establishing themselves by the 1850s. Two would emerge supreme under German American leadership, soon to become household names in this industry nationwide: Pfister and Vogel and Gallun. From the very beginning, the industry was composed principally of German immigrants, who defined it from the top management down to the floor workers. And by 1890, Milwaukee was producing more tanned hides than anywhere else in the world.

Industries such as brewing and tanning in Milwaukee were not only spearheaded by German Americans, they were also largely staffed by German Americans. German immigrants were attracted to these industries because they were reminiscent of the homeland, and ample work was available to serve growing demand. This created an interesting situation for German pioneers such as Guido Pfister, Frederick Pabst, and others. These "old Germans" had become quite accustomed to life in America and had shed much of their German customs and lifestyle. Although these great pioneers once came from the workers' ranks, they could no longer easily identify with these newcomers, despite being of the same sheaf and vine. They became the high society of the city.

While brewing and tanning came to be the largest industries in Milwaukee, other industries, such as milling, publishing, metalworking, and sausage making, were also strongly influenced by the city's German immigrants.

—Matt Hamacher and Tommy Hughes

German American brewers, employed by Miller, are pictured taking a break and relaxing. During the early to mid-1800s, the market for beer in Milwaukee was thoroughly competitive. By 1856, a mere 15 years after the founding of the first Milwaukee brewery, there were no less than 26 brewers in the area. Yet as the 19th century marched on with the Industrial Revolution and recurrent waves of German immigration, the market took on a more competitively monopolistic shade and exclusively German character. By 1876, the number of brewers had decreased to 18 and by 1885 to 9. Toward the end of the 19th century, certain German brewers began to win a competitive edge, becoming the Milwaukee beer barons, whose names are all familiar: Schlitz, Pabst, Miller, and Blatz. (Courtesy of the Wisconsin Historical Society.)

Valentin Blatz was from Mittenburg-on-the-Main, Bavaria. He immigrated in 1848, laying down his roots in pioneer Milwaukee. In Bavaria, he had taken up the brewing trade under the auspices of his brewer father. Having acquired enough capital by working as a foreman at several pioneer Milwaukee breweries, he soon ventured off on his own with a sum of $500 to found his own brewing enterprise. This new venture, the remains of which are located on the corner of Broadway and Juneau Avenue, grew under the skillful guidance of Blatz to be the third-most-productive brewery in Milwaukee by the 1870s. He was a considerable trendsetter, being the first proprietor to market his beer as a "Milwaukee Beer," as well as being the first in Milwaukee to sell his beer in bottles. It is these legacies for which he is remembered as one of Milwaukee's most dynamic and defining entrepreneurs. (Courtesy of the Milwaukee County Historical Society.)

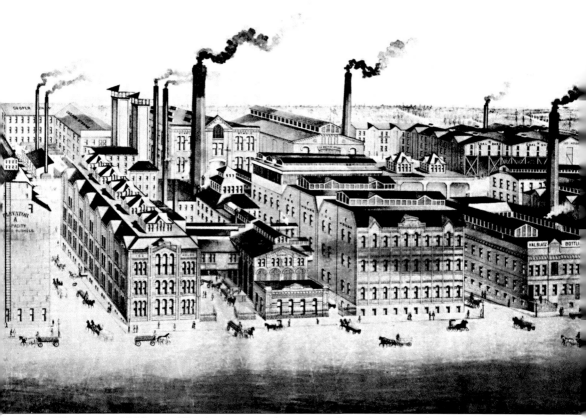

This view of Valentin Blatz's expansive brewery is from the time when it was in third place in the national beer industry, just behind Schlitz (1870s–1880s). Only two of the buildings rendered in this drawing remain today—the refrigerator and the former administrative building. The refrigerator is currently used for condominiums, and the offices of the administration building are used by the Milwaukee School of Engineering. (Courtesy of the Milwaukee County Historical Society.)

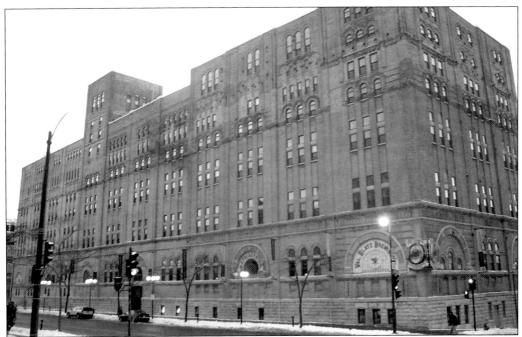

One of the last remnants of the Blatz Brewing Company today is a standing testament to German industry. This massive refrigerator building on the corner of Juneau Avenue and Broadway was only one of many Blatz Brewing facilities on the site. The old windows are filled in now, but a look through them 100 years ago would have yielded German brewery workers storing beer in refrigerated vaults to lager. The engraving on the side of the building reminds passersby today of the tremendous efforts put forth by German workers that helped build Milwaukee's defining industry. Note the intricate mosaic work that went into this engraving, showing that these buildings were indeed built to stand the test of time. (Courtesy of the Milwaukee County Historical Society.)

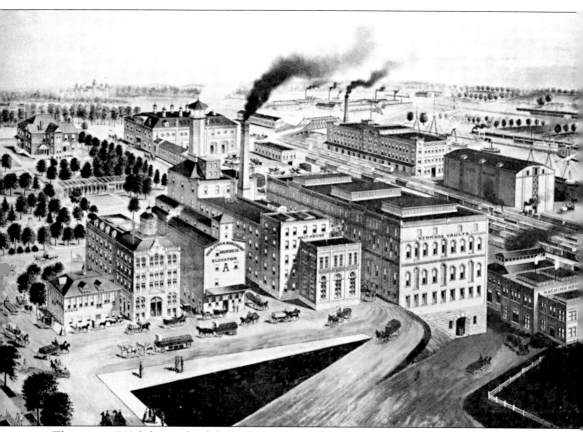

This is an 1892 lithograph of the Falk, Jung and Borchert Brewery (formerly Bavaria Brewery). The only remains of this leading brewery consist of the building labeled "storage vaults" and the stables, which are beyond the storage vaults and to the left, identifiable by the eight cupolas on its roof. At the brewery's height, nearly 200 men were employed here, bringing the brewery close to third place in the city's beer production by the 1890s. (Courtesy of the Milwaukee County Historical Society.)

This modern view is of the old Bavaria Brewery storage vault building looking northwest. Built in 1870, this building and the adjacent white stables are all that remain of the Falks brewing enterprise and are now the oldest brewery buildings still standing in Milwaukee. They are located on the south edge of the Menominee Valley, just off Twenty-ninth Street. The window patterns shown in this modern picture compare with those rendered in the 1892 lithograph of the Falk, Jung and Borchert Brewery (formerly Bavaria Brewery). A closer look at the remains of the Bavaria Brewery stables reveals the circular windows that can be matched with the lithograph rendition. In the lithograph, the stable building has eight cupolas on the roof. To the right of the photographer sits the storage vault building. (Courtesy of Matt Hamacher.)

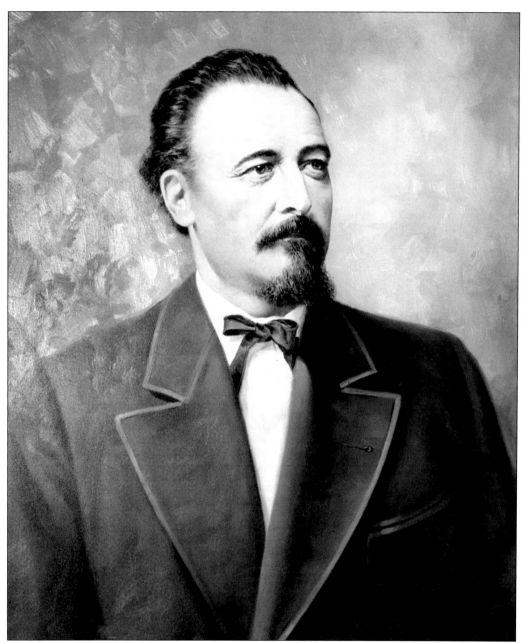

Frederick Miller was the founder and proprietor of what was to become Miller Brewing Company. He departed from his home in Riedlingen, Bavaria, for America in 1854 with his wife and son. Because he came to the United States financially well-off, he was able to buy himself some time to scout around for a favorable brewery location. A brewer before in Germany, Miller came to the United States with a master brewer's knowledge and a desire to brew quality lager beer. In 1855, he saw his opportunity and bought out an old failed brewery located west of the city that was owned by a member of the Best family. He called it the Plank Road Brewery. This brewery, now carrying his name, is still going strong on the very location that Miller picked out 153 years ago. (Courtesy of the Milwaukee County Historical Society.)

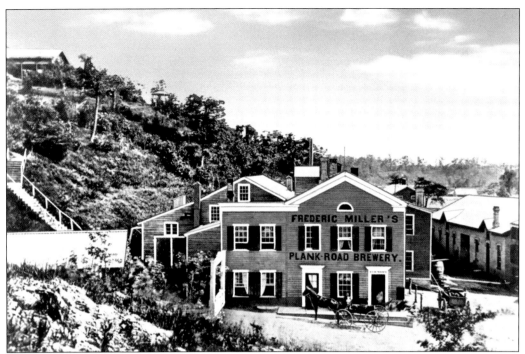

Frederick Miller's infant brewing enterprise began exactly where Miller Brewing continues to produce—on what was then known as Watertown Plank Road (State Street). Pictured here is the original Plank Road brewery. A replica of this brewery building can be seen on the present brewery site. Miller's beer garden can be seen in the picture to the left above the brewery. The Miller brewing enterprise is seen as it appeared in the 1880s and 1890s (below). At this time, Miller was trailing the market behind Schlitz, Pabst, and Blatz. Ironically, it is the last pioneer brewery still in operation today. (Courtesy of the Milwaukee County Historical Society.)

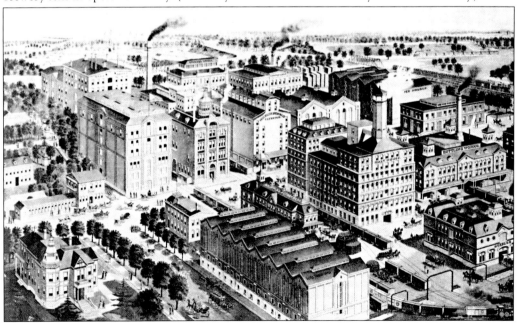

Miller Brewing is seen past and present—the last of the original German pioneer breweries in operation. In the foreground stands the old stable building, while the modern elevator building towers in the background. The historic Miller brew house has also remained standing, although it was moved. Interesting to note is the six-point star on the brew house. This is the *Brauerstern*, or brewer's star, which had been traditionally displayed on breweries in Germany for centuries. It is displayed on many of Milwaukee's older breweries. (Courtesy of the Milwaukee County Historical Society.)

Capt. Frederick Pabst rose from a steamer cabin boy to become Milwaukee's leading brewer by the latter decades of the 19th century. Hailing from the German state of Saxony, he came to the United States in 1848 and took a job on a Lake Michigan steamer out of Chicago. He was a rather late arrival on the brewery scene compared to his peers in the industry; only in 1862 did he take up the brewing trade under the apprenticeship of Jacob Best. Through a fortuitous marriage to Best's daughter as well as managerial expertise, Jacob Best took Pabst on as a partner in his brewery. By 1873, Pabst was leading the company that was to take on his name by the 1880s. This man not only did great service to the community through his strong contribution to the beer market, he also provided Milwaukeeans with relaxation and entertainment venues. He has gone down in history as one of Milwaukee's most influential and prominent citizens. (Courtesy of the Milwaukee County Historical Society.)

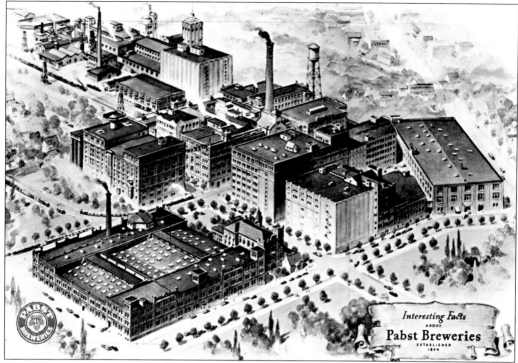

This lithograph is of the Pabst Brewing Company in the late 19th century, at a time when it was leading the local and national beer markets as well as drawing large profits from nationwide sales. Much of this complex can still be seen today at the west end of Juneau Street, as the brewery was in full operation here until 1996. (Courtesy of the Milwaukee County Historical Society.)

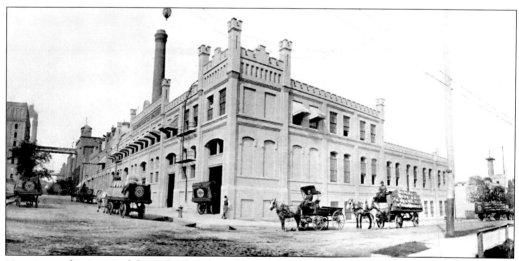

Here is another view of the Pabst bottling department's exterior around the early 20th century. Note the bustle of activity reflective of Pabst's success at this time. It is from here that armies of beer wagons would depart to take their coveted cargo to throngs of thirsty customers. (Courtesy of the Milwaukee County Historical Society.)

Joseph Schlitz was the founder and proprietor of Joseph Schlitz Brewing Company. After emigrating from Mainz, Germany, in 1850, he found a job at the pioneer Krug Brewery. By 1856, he had assumed a managerial position. Through a fortuitous marriage with the late Krug's widow in 1858, Schlitz assumed full proprietorship of the brewery and renamed it Joseph Schlitz Brewing Company—the flagship name that has become synonymous with Milwaukee beers. It is said that the company had the Chicago fire of 1871 to thank for its momentous leap forward in the Milwaukee beer industry, thereby seizing the opportunity to ship large quantities of product to the Chicago populace stripped of its own beer industry and eventually setting up a distribution point there. Joseph Schlitz met an untimely death when his steamer was wrecked off the coast of Wales in 1875 while returning from Germany. Nonetheless, the preparatory work he did before his death laid the groundwork for the brewery's incredible success in the late 19th and early 20th centuries. (Courtesy of the Wisconsin Historical Society.)

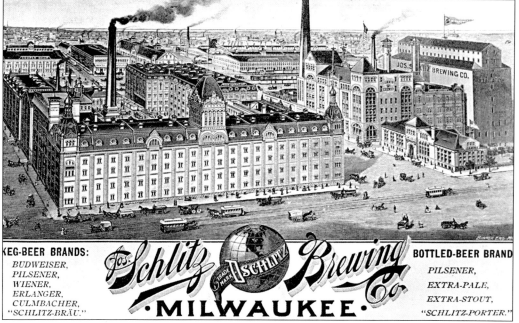

This lithograph of the Joseph Schlitz Brewing Company is from the 1890s. By this time, the company was second only to Pabst in production and nationwide shipping volume. After Joseph Schlitz's tragic death in 1875, leadership of the company transferred to the Uihlein brothers, who continued laying the foundation for the brewery's success in the 20th century. (Courtesy of the Milwaukee County Historical Society.)

This view is of a refrigerator building of the Joseph Schlitz Brewing Company. The Schlitz brew house was built in 1890 to meet a large local and national demand for its product. Apparently there was quite a demand for beer within the brewery as well. In 1886, a Schlitz manager boasted that his men consumed an average of 40 short beers a day, with one ambitious individual setting the record at 100! (Courtesy of Matt Hamacher.)

George Brumder was the founder and proprietor of the Germania Publishing Company. He came to Milwaukee in 1857, hailing from the area around Strassburg, Germany. His first professional activity in Milwaukee was the opening of a small bookstore in 1862 to serve Protestant Germans, which eventually evolved into the Verlag der George Brumder'schen Buchhandlun (Publisher of the George Brumder Bookstore). Germania Publishing Company's future flagship newspaper *Germania* was in fact owned by another publisher that used Brumder's Verlag to produce the publication. An example of a Brumder publication from 1900 is below. It is titled "Our War with Spain" and is reflective of the press's attempts at the time to blend Americanism with Germanism by promoting "our" American history while maintaining the German-language tradition. (Courtesy of the University of Wisconsin–Milwaukee.)

Guido Pfister was a Milwaukee tanning pioneer and enterprising businessman. Before coming to America in 1845, Pfister became intimately familiar with the tanning trade in his hometown of Hechingen, Germany. Arriving in Milwaukee in 1847, he set up a small leather store in the Menominee Valley that was to become the Pfister and Vogel Tanning Company by 1872. Under his guidance, the company was to become the largest tannery in the American Midwest. (Courtesy of the Milwaukee County Historical Society.)

Frederick Vogel was a native of Württemberg, Germany, and is most well known as the business partner of Guido Pfister and cofounder of the Pfister and Vogel Tanning Company in the Menominee Valley. After arriving in Milwaukee in 1848, he opened his own leather store and sold his product with the help of Pfister's budding tanning store. The two entrepreneurs soon consolidated their business expertise into one entity in 1853. By the dawn of the 20th century, the tannery was the largest in the world. (Courtesy of the Wisconsin Historical Society.)

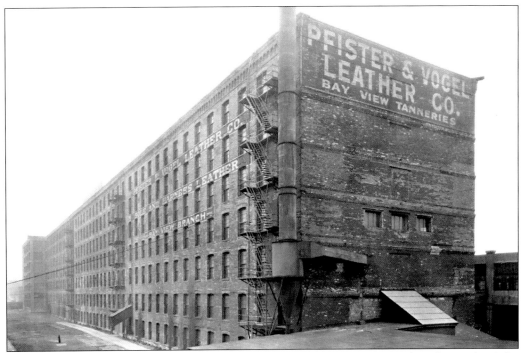

The tanneries of Pfister and Vogel would become the world's largest in the aftermath of the Civil War, dominating the local market by the mid-1880s. Pfister and Vogel's Bay View tannery boasted a scale that could be considered giant even by modern standards. At the time, this was only one of Pfister and Vogel's four tanneries in the Milwaukee area, all equally large in scale. The location of the company's first tannery was in Walker's Point, just west of today's Sixth Street viaduct. When Guido Pfister and Frederick Vogel became business partners in 1853, they could never have known just how beneficial their efforts were to be to the Milwaukee and even national economy. (Courtesy of the Milwaukee County Historical Society.)

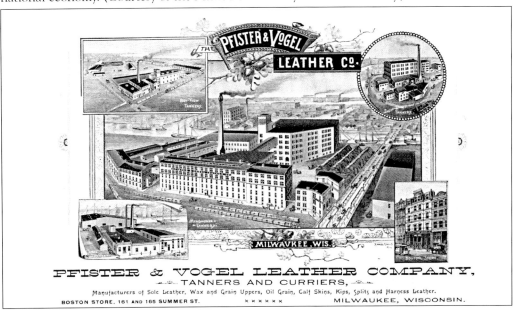

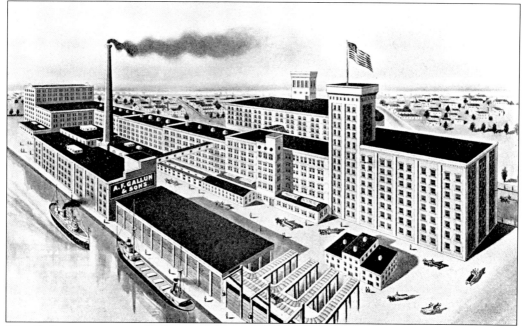

The Gallun tannery on the upper Milwaukee River is seen in its heyday. This tannery was the product of the innovation of August Gallun, who had begun his career in Milwaukee in partnership with Albert Trostel, another tannery proprietor, in 1858. Above, the former Gallun tannery is seen as it appears today (below), on the opposite side of the river, looking south from North Avenue. This area along the upper Milwaukee River was at one point referred to as "Tannery Row." Gallun was neighbored by Pfister and Vogel and Trostel in the last decades of the 19th century. All these tanneries were located on waterways to facilitate easy delivery and shipment of goods. (Above, courtesy of the Milwaukee County Historical Society; below, courtesy of Matt Hamacher.)

Five

The Art of German Milwaukee

Germans immigrating to Milwaukee were praised throughout the country for their strong appreciation of fine arts, including visual arts, music, and theater.

The first German artist to settle in Milwaukee was Henry Vianden (1814–1899). He came from Germany to the United States in 1849 at the age of 35 and the following year settled permanently in Milwaukee. Trained in Munich, Vianden was a painter, engraver, and lithographer, and soon after immigrating to Milwaukee, he became the city's leading professional artist.

Also famous in Milwaukee were the German panorama painters, who immigrated to the city in the late 1880s specifically to pursue this art. They worked for the American Panorama Company, the Northwestern Panorama Company, or later panorama companies—all owned, operated, and staffed by Germans. Most German artists stayed in Milwaukee to work as art teachers, scenery painters, portrait artists, or in other professional arts positions, continuing to influence the culture of the city.

Music and theater were also appreciated and fostered in Milwaukee by German immigrants. Originally the musical atmosphere of the German community in Milwaukee consisted mainly of bands in beer gardens and singing societies. This atmosphere blossomed, in its prime, into the Musical Society of Milwaukee. Music also helped pave the way for German theater in Milwaukee. Early musicals were generally local to neighborhood groups and were held as charity events for families in need. However, in 1850, a number of middle-class merchants and business owners decided to expand the repertoire and form amateur theater troupes. The first German theater performance was given in what is now the Third Ward. And German theater remained a local amateur entertainment until the mid-1860s, when Henry and Joseph Kurz successfully launched the Stadt Theater, built on the grounds of the current city hall. It was followed by the New German City Theater (Das Neue Deutsche Stadt Theater), which showcased German as well as English-language talent.

The recognition of Milwaukee as a German art center is still alive today and can be seen at the Milwaukee Art Museum as well as buildings throughout the city.

—Corrin Christopher, Nicole Diesing, Derek Schaefer, and Anne Schumacher

Michael Lenk emigrated from Germany to America in 1911 and settled in West Allis. He had no formal training as an artist and did not begin painting until he retired from Allis Chalmers. Most of his paintings are watercolors or oils and portray northern Wisconsin, Native Americans, or the Bible. This painting, called *Father Claude Allouez at La Point*, depicts the Jesuit missionary who came to the Apostle Islands in northern Wisconsin in the 1660s. (Courtesy of the Museum of Wisconsin Art.)

Henry Vianden is one of the most famous German American artists from Milwaukee. This painting is called *Landscape with Mountains and River*, and it shows the landscapes and trees for which he is so famous. Recognized now as an important early regionalist painter in the Midwest, Vianden taught art classes at his studio, two different schools, and in his own home. Numerous students of his went on to be successful artists themselves. (Courtesy of the Milwaukee Art Museum.)

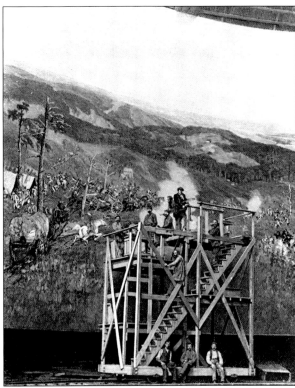

Panorama paintings were extremely popular in the 1880s. European panoramas shown throughout the world as traveling exhibits inspired German artists to come to Milwaukee specifically to commercially paint panoramas. Depicted here are several artists, including Franz Biberstein, Hermann Michalowski, Peter George, Richard Lorenz, Friedrich Heine, and Franz Rohrbeck, working on a portion of the Atlanta Cyclorama at 628 Wells Street. (Courtesy of the Milwaukee County Historical Society.)

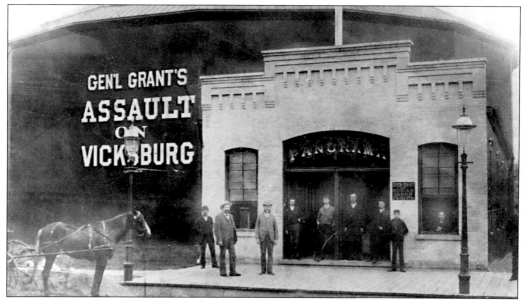

In 1885, the Northwestern Panorama Company built the 16-sided panorama building, shown here, on the southwest corner of Cedar Street and Sixth Street. The building could hold 150 viewers and was 125 feet in diameter. The only panorama exhibited in this building was *General Grant's Assault on Vicksburg* from July 1885 until the end of 1887. The Northwestern Panorama Company was founded in 1884 by a co-op of individuals including Louis Kindt and Otto Osthoff. (Courtesy of the Milwaukee County Historical Society.)

Milwaukee was home to a number of German American artists who enjoyed religious art. These altar paintings at Trinity Evangelical Lutheran Church were painted by Friedrich Wilhelm Wehle when the church was built in 1880. Wehle was born in Neu Jonsdorf, Saxony, in 1831 and immigrated to the United States in 1866. As a young man in Germany, he received some instruction in painting in Dresden. He settled in Milwaukee in 1879. (Courtesy of the Milwaukee County Historical Society.)

Another German American religious painter in Milwaukee, and one of the very few female artists of the time, was Clothilda Brielmaier. She spent several years in Munich and Rome studying art. Credited in art history records as the first woman to establish her own art studio in the United States, she was an accomplished artist equal to her male counterparts. Some of her large portraits can be found in historical museums throughout the United States. Her talent is demonstrated here in the *Memorial Portrait of Camilla Kopmeier*. Brielmaier painted the chapel at the St. Francis Convent in Milwaukee. (Courtesy of the Milwaukee County Historical Society.)

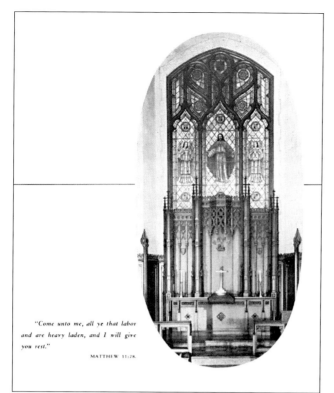

German American Carl Reimann, born, raised, and educated in Milwaukee, was a religious painter and stained glass designer. His father was a Swiss immigrant and his mother a German immigrant. Reimann studied at the Weimar Art School in Germany. His firm, the Carl A. Reimann Company, decorated the Cross Evangelical Church in Milwaukee as well as other churches throughout the country. Pictured here is a sample of his work. (Courtesy of the Milwaukee County Historical Society.)

The Conrad Schmitt Company was established in 1889 in Milwaukee. The son of Bavarian immigrants, Conrad Schmitt founded a renowned company of high standards that still today is one of the premier decorative painters and restorers of landmarks, cathedrals, churches, and theaters in the United States and Canada. The company began the restoration of the Pabst Theater in 1975, returning the theater to its 1895 opening night splendor. (Courtesy of Conrad Schmitt Studios and John J. Korom.)

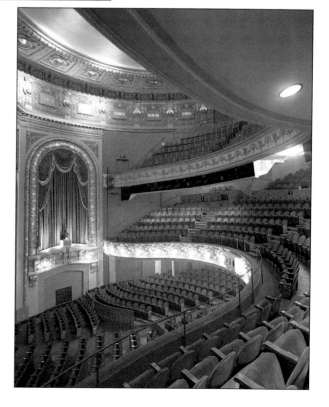

Hugo Broich worked as a lithographer, photographic painter, and most famously as a photographer when he came to Milwaukee in 1857. He owned his own studio located on Spring Street (now Wisconsin Avenue), which also had a gallery where Broich would display his and other artists' work. His portrait of William Parks Merrill, shown here, is said to be the best of his small amount of surviving work. (Courtesy of the Milwaukee County Historical Society.)

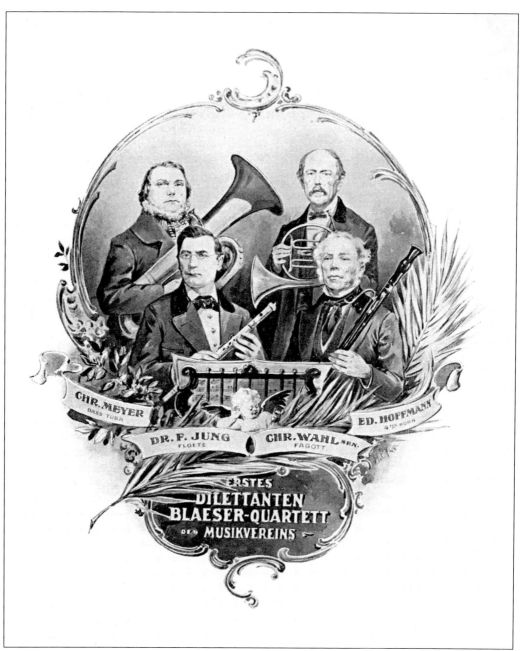

The Erstes Dilettanten Blaeser-Quartett des Musikvereins (the First Dilettant Brass Quartett of the Musical Society) was a collection of instrumentalists from the Musical Society of Milwaukee (1850–1848), known in German as Der Musikverein von Milwaukee. Notably directed by Hans Balatka and Christopher Bach, the musical society was established by Theodore Wettstein in an effort to bring Milwaukee's musical virtuosi together. (Courtesy of the Milwaukee County Historical Society.)

One of the Musikverein's legendary directors was Hans Balatka (1826–1899). Also a founder of the Northwest Sängerbund, or singing society, Balatka took a risk in 1853 by directing the Musikverein in Milwaukee's first German opera, *Czar und Zimmerman* ("czar and ship carpenter") by Albert Lortzing. This first opera was a success, and many more followed. (Courtesy of the Milwaukee County Historical Society.)

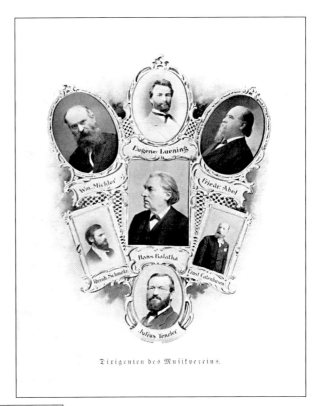

This advertisement is for the first opera performances of the musical society. Among the operas performed were the *Czar and Zimmerman* and the Revolutionary War themed *Mohega, the Flower of the Forest*. A conductor from Berlin, *Mohega*'s composer and producer, Eduard de Sobelewski, was of German and Polish heritage. Schlitz Park hosted the first locally staged open-air grand operas. (Courtesy of the Milwaukee County Historical Society.)

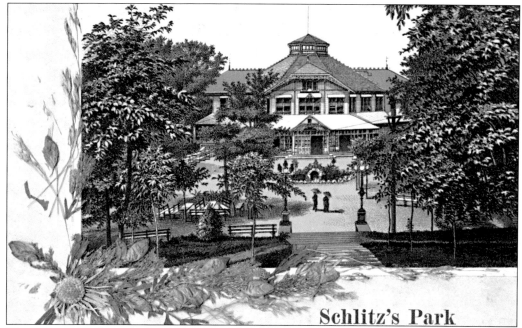

This postcard is from the North American Sängerfest, a singing festival held in Schlitz Park in 1886. German singing groups gathered from across the nation. Some 1,000 adults and 800 children made up the Milwaukee mixed chorus alone. Schlitz Park was popular for outdoor concerts. On Sunday afternoons, Christopher Bach and his orchestra would also perform. (Courtesy of the Wisconsin Historical Society.)

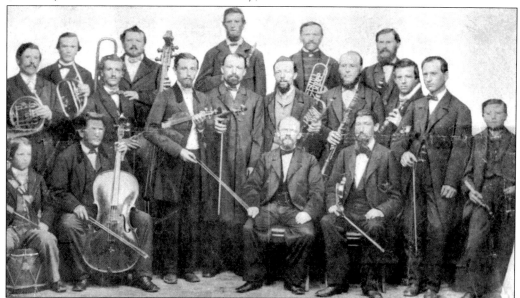

Christopher Bach (1835–1927) is seen above, center, with his orchestra. Bach, born in Prussia, made a career at the Musical Society of Milwaukee and as a staff member at the Wisconsin College of Music. Bach was also a composer and the musical director of the German Theater and the Pabst Theater. His son, Hugo, was professor of cello at the conservatory and led the Bach Orchestra, among other accomplishments. (Courtesy of the Milwaukee County Historical Society.)

Both Hugo (1863–1932) and William Kaun (1877–1922) played a large role in the German American music scene of Milwaukee. Hugo (right) served on the staff of the Wisconsin Conservatory of Music and also as the director of the Milwaukee Liederkranz and Milwaukee Männerchor. He was credited by critics as the leading composer of his time despite being a contemporary of Richard Strauss. His brother, William, had a successful business in sheet music publishing (below) and was known for giving unknown artists, including women, a chance to publish their compositions. William was also credited with an unusually great knowledge of music for someone in the commercial end of the musical business, and his relatively young death was a shock to many. (Courtesy of the Milwaukee County Historical Society.)

The German singing societies, *Gesangvereine*, of Milwaukee bring together people who share the love of singing German songs. In 1847, the first male singing quartet formed and exploded into a collection of men's choruses before the year ended. These *Männerchöre* are one of the more popular forms of singing societies. The above Milwaukee Liederkranz has been singing since 1878. (Courtesy of the Milwaukee County Historical Society.)

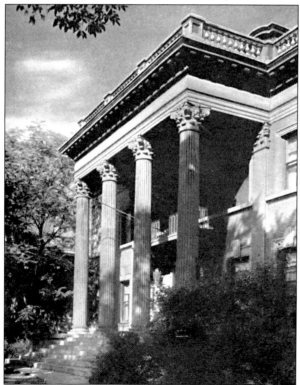

The Wisconsin Conservatory of Music has had a complicated history. Its origins lie in two different organizations, the Wisconsin College of Music and the Wisconsin Conservatory of Music, each founded by German families. Over the years, the two schools have merged and separated several times, finally uniting in 1968 as the Wisconsin Conservatory of Music, located on Prospect Avenue. (Courtesy of the Milwaukee County Historical Society.)

Most of the original German brass bands are now social groups. The Spielmannszug Drum and Bugle Corps is a splinter of an original group from Chicago. In Milwaukee since 1957, the group hosts many Carnival-related parties like the Lumpenball featured here. The prince and princess of the Lumpenball are crowned for being the "raggediest couple" at this hobo-themed dance. (Courtesy of the Milwaukee County Historical Society.)

The above group is dancing to some polka music. The German polka is one of four varieties and is called the "Dutchman polka." Using "Dutch" to distance the polka from Germany when it was first gaining popularity in America after World War II, polka in the United States originally had a jazz or swing feel. But since then traditional German polka, with the tuba as its "brass bass line," has increased in popularity. (Courtesy of the Milwaukee County Historical Society.)

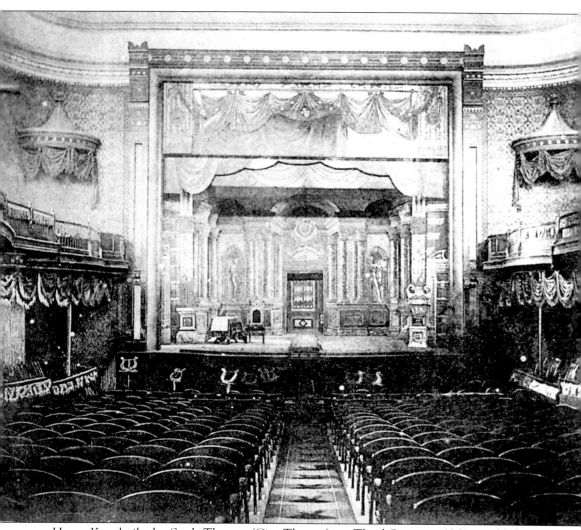

Henry Kurz built the Stadt Theater (City Theater) on Third Street in 1868, establishing the first German theater in Milwaukee. The theater could hold 1,000 people. Often featured were performers from his Kurz German Stock Company. To initially raise attendance, for it was difficult to fill 1,000 seats, English-language performances were introduced alongside the German performances. An arrangement was made with the City of Berlin to import German talent to perform at the Stadt Theater. Under the direction of Christopher Bach, the orchestra was "compared favorably with that of the Berlin Theater." (Courtesy of the Milwaukee County Historical Society.)

One of the premier German productions featured at the Stadt Theater was Johann Strauss's *Die Fledermaus*. This announcement for the operetta boasts that it was the first performance in Milwaukee. It was slated for Wednesday, April 9, 1879. (Courtesy of the Milwaukee County Historical Society.)

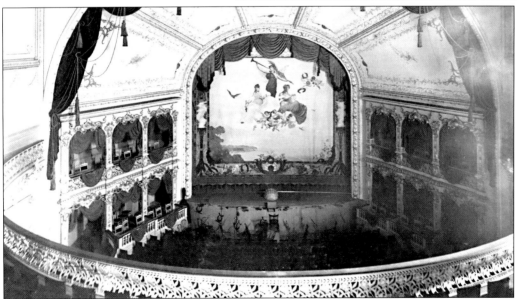

The Nunnemacher Grand Opera House was built by the Swiss-born Jacob Nunnemacher in 1871 and was located on Water and Wells Streets. Although the opera was well attended by the elite, it could not sustain itself. In 1890, shortly after acquiring the Kurz acting troupe, Capt. Frederick Pabst purchased the Nunnemacher and renamed it the Das Neue Deutsche Stadt Theater (the New German City Theater), where performances were once again done in German. (Courtesy of the Milwaukee County Historical Society.)

Here is a program cover for a concert performed by the Milwaukee Music Society at the luxurious Pabst Theater located on Water and Wells Streets. The concert, held on Tuesday, February 18, 1896, was held not too long after the new Pabst Theater was built out of the ashes of the Das Neue Deutsche Stadt Theater, which burned down in 1895. (Courtesy of the Milwaukee County Historical Society.)

Leon Wachsner was the first manager of the Pabst. Here is the acting troupe of 1901. The Pabst Theater was hailed by many performers as one of the best places to perform due to the wonderful acoustics. The theater has undergone renovations to ensure that the Pabst Theater continues in the lavish fashion in which it did at the end of the 19th century. (Courtesy of the Milwaukee County Historical Society.)

Six

THE SOCIAL SCENE

The Germans who immigrated to Milwaukee brought with them not only a pride in their culture but also their social traditions.

Soon after arriving in Milwaukee, Germans began to form *Vereine* (societies) and clubs, where they could maintain their interests and traditions. Some of the early Germans to come to Milwaukee, the 48ers, started the Turnerverein, the gymnastic society, where health and fitness, for both mind and body, as well as group work and tradition were stressed through physical and mental activity. They also produced three very popular German newspapers as well as contributing to the founding of the German English Academy. The Turnverein is still an active German American society today.

Claimed to be the first German club of Milwaukee, the Deutscher Club was founded in 1891 by three businessmen, Gen. F. C. Winkler, George Koeppen, and Henry Gugler, who met with 60 other German American men at the Plankinton House Hotel in order to create a social club that provided and promoted German American understanding and fellowship. Many other German American social clubs were also founded around this time, and today there are over 40 such German American social clubs in the Milwaukee area.

Clearly festivals were and are an important part of German American socialization. Germanfest, started in 1981, is a way for the German Americans of Milwaukee to showcase their clubs and societies as well as to inform others of their traditions, music, food, dance, and clothing. From the beginning of their arrival in Milwaukee, German Americans maintained the traditional German festivals that they celebrated in the old country, inviting not only German Americans but all Milwaukeeans to celebrate with them. The list of festivals is almost endless; some of the more traditional ones still celebrated today are Schlachtfest (Slaughter Festival), Fasching/Karneval (Mardi Gras), Mai Fest (May Festival), Oktoberfest, and Traubenfest (Grape Festival), let alone all the different balls, such as Maskenball (Masquerade Ball) and Lumpenball (Rascal Ball).

It is through socializing that German Americans pass on their traditions to their children, teach others about who they are, and maintain the "German Athens of the U.S." that is known as Milwaukee.

—Jeanette S. Brickner, Anna Petrofsky, and Heather Wojciechowski

Here a German American family gets together on a Sunday to catch up on the news, play cards, and drink a little beer. Socializing for German Americans did not and does not only occur at major events, though. One of the most famous traditions Germans brought with them from the old country was their love of food, beer, and good talk. When Germans first arrived in Milwaukee, they very soon established places to meet where they could enjoy all three. Beer gardens were very popular meeting places, and most major breweries, such as Pabst, Miller, and Schlitz, offered the German American population a place to go. Much to the horror of the Anglo-Saxons, Germans would often meet with their families at these gardens on Sunday afternoons where they would eat and drink a beer or two. Many of the gardens had entertainment for the whole family, including horse racing, live music, plays, and musicals. Some beer gardens were more formal, such as the Schlitz Palm Garden, which was elaborately decorated and could hold up to 450 people. Today these beer gardens no longer exist. However, there is still a plethora of German restaurants in Milwaukee that offer good German food and beer and a *gemütlich* place to sit and talk. (Courtesy of the Wisconsin Historical Society.)

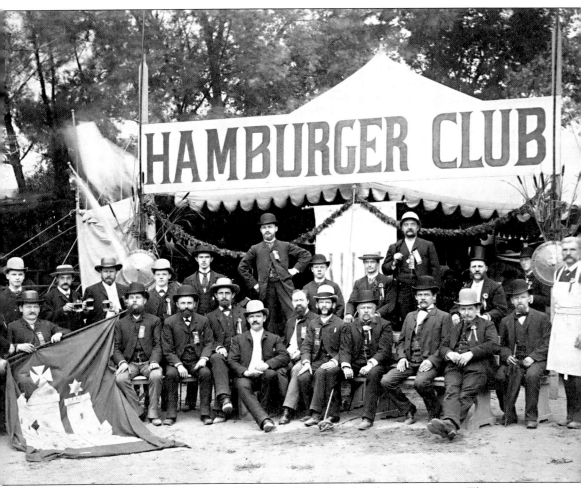

There were and are many German social clubs in Milwaukee that focus on regions. This picture is from the late 1880s and shows a group of men who themselves or whose families emigrated from the Hamburg area of Germany, as demonstrated not only by the sign but also the flag proudly displayed. (Courtesy of the Milwaukee County Historical Society.)

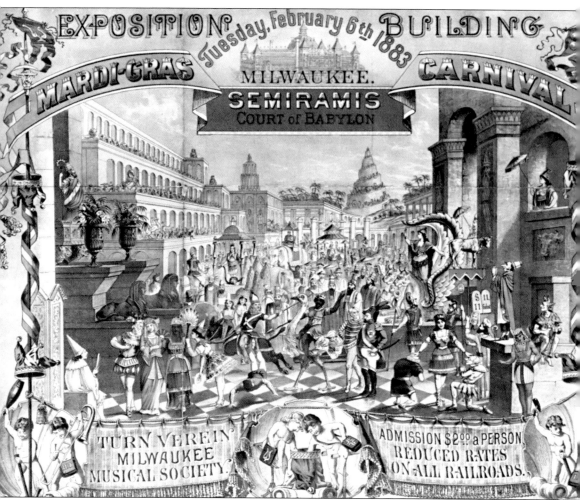

The Turner Society is known for hosting many events in and around Milwaukee, including an annual Carnival celebration. Carnival is a popular celebration in Germany and other countries, and is the last day before the beginning of Lent. The flyer above advertises the Turner Society's 1883 Carnival celebrations. The $2 per person admission would have been quite expensive in 1883, demonstrating that this event was catering to an upper-class clientele. (Courtesy of the Milwaukee County Historical Society.)

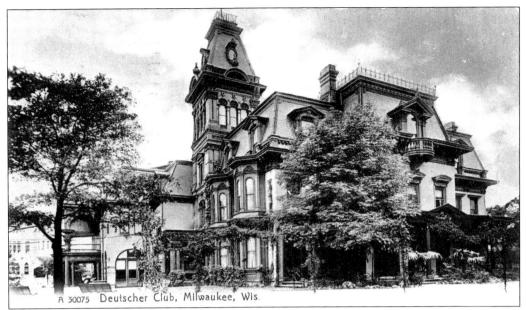

The Deutscher Klub (German Club), now the Wisconsin Club, is a social club that began in 1891. When the club's original home in the old opera house burned down in 1894, the club faced a crisis. However, despite financial difficulties, the club arranged the purchase of the Mitchell Mansion (located on Wisconsin Avenue) in 1895. The opulent building is still the home of the Wisconsin Club today. It was and is primarily a social club, but its original goal was to promote the concept of German Americanism. Above is a photograph of the exterior of the building. (Above, courtesy of the Wisconsin Historical Society; below, courtesy of the Milwaukee County Historical Society.)

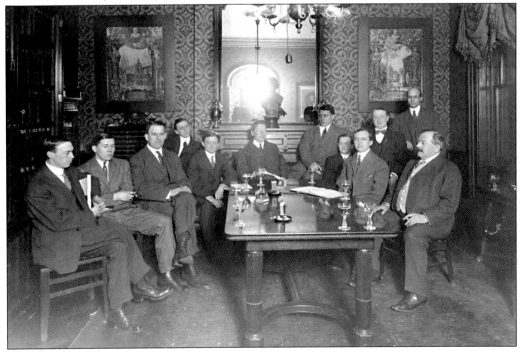

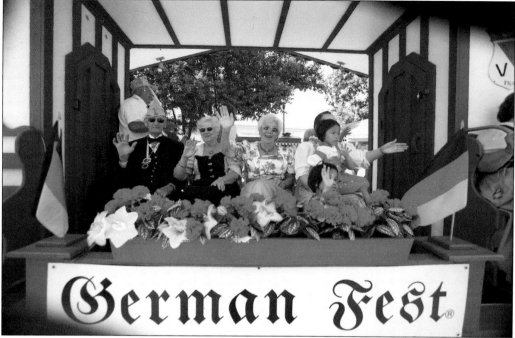

German Fest has been held annually in Milwaukee since 1981. The four-day-long celebration is the largest German cultural celebration in North America and offers many attractions, including singers, musical groups, and cultural displays from Germany, Switzerland, Austria, the Milwaukee area, and other parts of the globe with German cultural heritage. Most of the German cultural clubs in Milwaukee participate in the festival on one level or another. Booths are set up to showcase organizations and crafts, and a parade is also held. German food and beer, both local and imported, is sold at the event. One of the more unique attractions is the Dachshund races. The four-day festival is always held Thursday through Sunday the last full week in July. (Courtesy of Germanfest.)

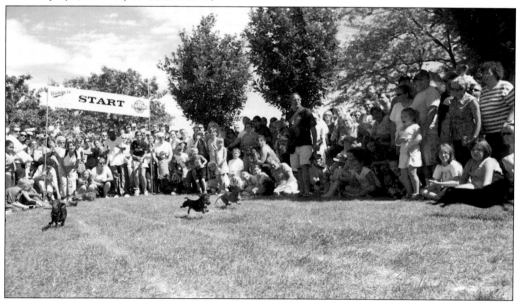

Pictured here are the Schlachtfest celebrations, held on the last Saturday in January. The festival revolves around traditional bratwurst making. Prior to 2005, the Apatiner Society held the annual Schlachtfest; they then passed the tradition on to the Danube Cultural Society. Schlachtfest is held at the Sacred Heart Croatian Hall. Dessert is the highlight of the event, with homemade cookies delivered to each table. (Courtesy of the Danube Cultural Society.)

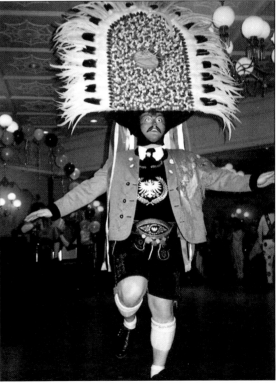

Two competing Maskenballs (masquerade balls) are currently hosted in Milwaukee during the early months of the year. One of the balls is held by the Spielmannzug Group and the other by the Rheinischer Verein. The Maskenball is one of several distinct traditional Carnival celebrations. Costumes are worn, and prizes are awarded to the best. Here a member of the Muller Fasching Verein performs at the Rheinischer Verein Maskenball. (Courtesy of Petra Theurich.)

Kirchweih is a festival that has been held since at least the fifth century in German-speaking areas. The celebration originally was intended to celebrate the consecration of a Christian church in a town. Today the Danube Cultural Society hosts Kirchweih (usually in October) as a way to celebrate its traditions—the children and youth groups are particularly involved in the festival, as seen in this picture. (Courtesy of the Danube Cultural Society.)

German American Day is October 6. The annual Miss German American Society Contest is held every year in the beginning of October during the German American Day dinner/celebration. The winner receives a cash prize, the responsibility of attending many of the German community events, and a tiara and sash for a whole year. From left to right are Rolf Theurich, Wilma Giese, Petra Theurich, and Gisela Theurich. (Courtesy of Petra Theurich.)

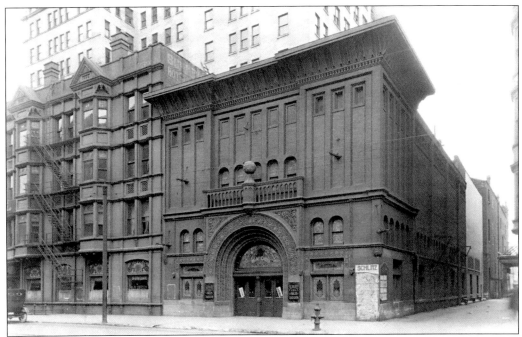

The most famous Milwaukee beer garden was the Schlitz Palm Garden. It opened in 1896 on what was then Grand Avenue (now Wisconsin Avenue) and Third Street. This opulent beer garden was a major landmark in the city. During Prohibition it was converted into the Garden Theater, which was eventually demolished. The Grand Avenue Mall's main entrance is now located where the building once stood. At the height of its operations, up to 40 barrels of Schlitz beer were served there per day. It was a popular venue for its atmosphere and its entertainment possibilities and had its own organ and in-house band. (Courtesy of the Milwaukee County Historical Society.)

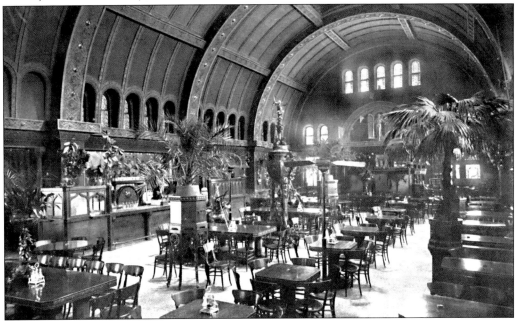

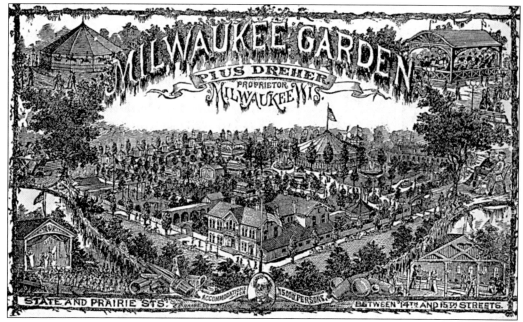

Beer gardens were very popular places for German Americans to meet, when the weather allowed. Pictured here is an advertisement for the Milwaukee Garden, run by Pius Dreher and located between State and Prairie Streets. (Courtesy of the Wisconsin Historical Society.)

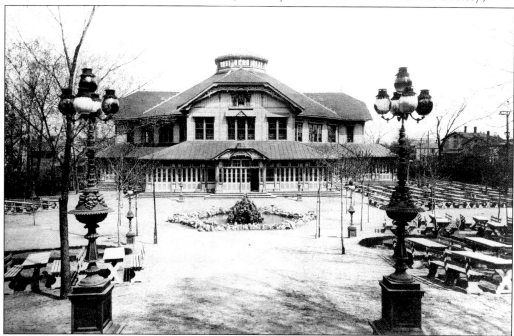

The Schlitz Park beer garden stood at Eighth and Walnut Streets in Milwaukee. It was opened in 1879 and housed a pavilion, zoo, and two fountains. Operas and concerts were performed there in the summer featuring nationally and internationally known musicians. It is not to be confused with the current Schlitz Park, which is an office park housed in the old Schlitz Brewery buildings. (Courtesy of the Milwaukee Public Library.)

The Pabst Park beer garden was located at North Third Street and West Garfield Avenue. Here a group of people enjoy a summer day in the park. (Courtesy of the Wisconsin Historical Society.)

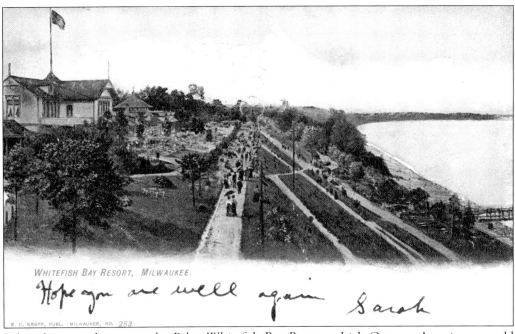

Pabst also owned a resort, the Pabst Whitefish Bay Resort, which German Americans would visit on the weekend in order to relax and socialize outside the city. The resort was located just north of Milwaukee. It drew large crowds from Milwaukee on weekends from its establishment in the 1880s until it closed in 1914. Guests would board steamers in downtown Milwaukee and disembark at the park's lakefront, then climb up the bluff to enjoy the attractions, which included a Ferris wheel and a merry-go-round. (Courtesy of the Wisconsin Historical Society.)

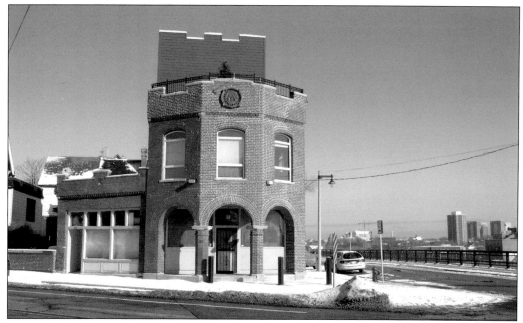

Tied houses were also places where German Americans would meet and socialize. A tied house was a type of tavern that had a brewery for a sponsor. Prior to Prohibition, many bars in Milwaukee had such an arrangement. Schlitz, Pabst, Miller, and other large breweries would buy profitable corner locations throughout the city and franchise them out on the condition that the bar would only serve their product. As most alcohol consumption during this time took place in taverns, this was a very profitable business for both the breweries and for the franchises. Pictured is an old Miller tied house located on Holton and Reservoir Streets. (Courtesy of Jeanette S. Brickner.)

"Ghost signs" are advertisements that were painted on brick walls before the advent of billboards. Many brewery ghost signs can be seen around town. Above is a well-preserved ghost sign painted on what is now the Riverwest Co-op on the corner of Fratney and Clarke Streets. (Courtesy of Jeanette S. Brickner.)

Karl Ratzsch's is a restaurant located on Mason Street in downtown Milwaukee. The restaurant was originally founded in 1904 by Otto Hermann under the name Hermann's Cafe; the name was later changed to Karl Ratzsch's when Hermann's son-in-law Karl and stepdaughter Helen later took over operations. (Courtesy of Karl Ratzsch's.)

Mader's has been voted the most famous German restaurant in North America. It was founded in 1902 by an ambitious young German immigrant, Charles Mader, at 233 West Water Street (now Plankinton Avenue). He called his place the Comfort and started serving up German fare. Dinner, including tip and beverage, was 20¢, and Cream City beer was 3¢ a stein or two for a nickel. Later the Comfort moved to Old World Third Street and was renamed Mader's, as seen here in 1940. (Courtesy of the Wisconsin Historical Society.)

Still today it is important to the German Americans of Milwaukee to pass on their culture and traditions to their children. Pictured here is the Danube Cultural Society's youth group in traditional Danube Swabian dress. There are approximately 15 German clubs in Milwaukee that specifically concentrate on a German region. (Courtesy of the Danube Culture Society.)

Seven
WOMEN OF GERMAN MILWAUKEE

Female German immigrants played an extremely important role, both privately and publicly, in creating the fabric of what is today Milwaukee.

These women brought with them their language, their food, and their ideals and used all these tools to raise good German American citizens. Der Grünemarkt (Green Market) was set up in the heart of the German area of Milwaukee and was a place for women to buy their produce, meats, cheeses, and breads for their families. It was also a place to socialize. These encounters at the market soon led to the creation of numerous German American women's organizations. Between the years of 1844 and 1914, German women founded over 300 associations, clubs, organizations, and unions, which served a variety of social, athletic, philanthropic, or educational purposes for immigrants.

One very outspoken member of the numerous women's groups was Mathilde Franziska Anneke (1817–1884). Her powerful lectures spanned in topic from German literature to women's suffrage. In 1852, Anneke succeeded in founding the first women's newspaper in the United States, *Deutsche Frauen-Zeitung* (German Women's Newspaper). And she also took over the school Töchter-Institut (Daughters' Institute) and revised its teaching methodology.

Margarethe Schurz was another German woman who played a key role in the education of Milwaukeeans. Schurz came to the Milwaukee area in 1856 with her husband and children and brought with her the ideas of Friedrich Fröbel, including the concept of the kindergarten. Schurz decided in 1856 to open the very first kindergarten in the United States. Soon thereafter the kindergarten concept spread throughout the area and then the nation.

Another German woman who was highly involved in Milwaukee's education system was Meta Berger. Berger was a teacher at the normal school, a teachers training college, where she met her husband, high-profile Socialist Party member Victor Berger. By 1909, Meta was herself a recognizable socialist and was eventually elected to the school board in Milwaukee.

Without the efforts of German women, Milwaukee would not have developed and maintained its German flavor and its citizens certainly would not have become the people they are today.

—Amanda Linden, Ashley Hafemann (Gehr), and Robyn Leidel

Mathilde Franziska Anneke is perhaps the most internationally recognized German American woman of Milwaukee. She was a 48er who immigrated with her husband to Milwaukee in 1849 where she continued to fight for the ideals of the 1848–1849 revolution. She strongly supported the abolitionist cause and also carried on the battle for women's rights. Her journalistic and literary work was inseparably intertwined with her political, social, and pedagogic activities in Milwaukee. (Courtesy of the Wisconsin Historical Society.)

German women in Milwaukee were expected to keep the house, raise the children, cook for their families and husbands, and in general keep the household running smoothly. The picture above is of Minnie and Louise Dick. This is an intimate look at the inside of a typical German Milwaukee household during the mid-1800s. Whether it was cooking for the family, caring for the children, or cleaning the house, the German American wife and mother was the one who held the family together. (Courtesy of the Milwaukee County Historical Society.)

The German public market was a staple in the German community in Milwaukee, pictured here in the 1850s looking down East Water Street. It was called a beehive of small trade as almost anything could be found there. Located in what was then the heart of downtown, it was a hub for German women to get together while purchasing their daily commodities. The market was nicknamed "the Green Market" because of the fruits and vegetables that were sold there. (Courtesy of the Wisconsin Historical Society.)

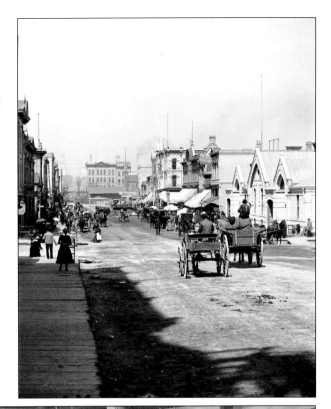

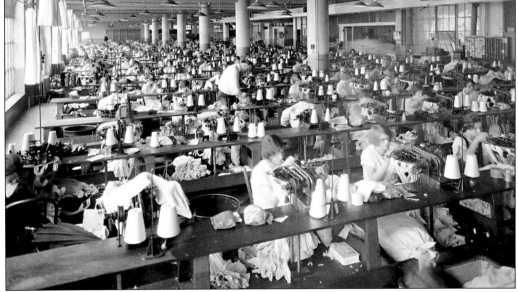

Despite their duties as wives and mothers, many German American women immigrants sought employment outside the home. Although some women chose to receive a formal education in one of the many German schools, some chose to go right into an industry job. A very popular and accepted position for these women at the time was the production of clothing. German women at the time also held jobs as secretaries, teachers, and nurses. (Courtesy of the Milwaukee County Historical Society.)

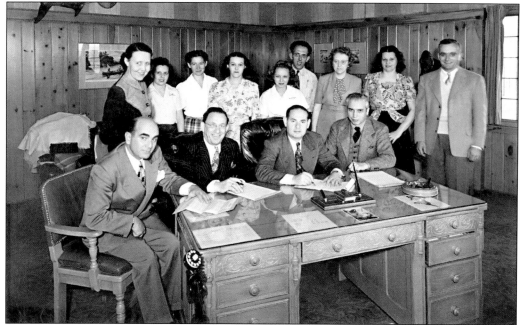

The Ladies International Garment Workers Union, like the Seamstresses Union, was one of the largest unions in the United States with predominantly female membership. It was a key player in labor history in the 1920s; however, before that the important sector of this union, located in Milwaukee, played a large role. (Courtesy of the Milwaukee County Historical Society.)

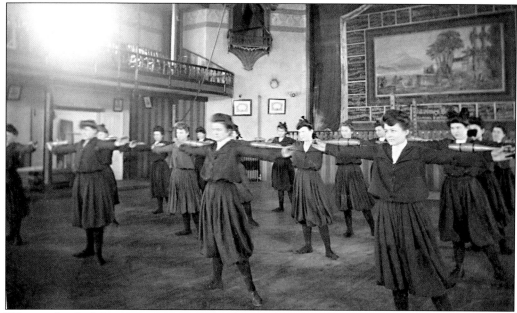

When a flood of German immigrants first began arriving in Milwaukee in the mid-1800s, they quickly began establishing Turnervereine (Turner Societies). In the early years of the Turner Societies, membership was restricted to men. In the year 1882, women's auxiliaries to Turner Societies were introduced. The auxiliaries focused on socialization with others and on recreational activities, especially dance and gymnastics. (Courtesy of the Milwaukee County Historical Society.)

One of the main focus points for the women's Turner Auxiliaries was socialization. Creating friendships and bonds with other German women was a way for German American women to keep their culture and heritage alive while finding a new life in Milwaukee. The playful picture at right is a product of one of the Milwaukee Turnvereine. (Courtesy of the Milwaukee County Historical Society.)

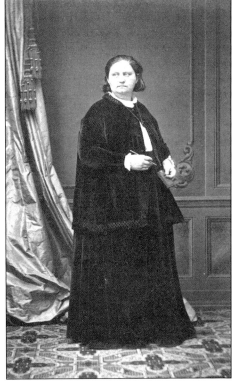

Mathilde Franziska Anneke was a very powerful and commanding speaker, especially when the subject of her speech was women and equal rights. Having fought for the rights of people in Germany, her efforts were carried over to newfound passions in America. Her ability to speak so powerfully allowed her to grab and hold the attention of her audience. Anneke even went to Washington, D.C., to speak out publicly and lobby for women's rights. (Courtesy of the Wisconsin Historical Society.)

The *Deutsche Frauen-Zeitung* was the first women's newspaper in the United States. Established in Milwaukee in 1852, it was headed up by women's suffrage leader Mathilde Franziska Anneke. The paper, in English and German, was published and worked on only by women as a way to speak out for equal rights for women. (Courtesy of the Wisconsin Historical Society.)

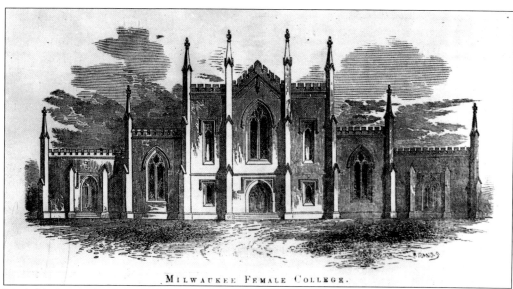

Mathilde Franziska Anneke's renowned private girls' school, the Töchter-Institut, opened in 1865 in Milwaukee. The school was open for 18 years, and all classes were conducted in German. Anneke believed that education was key for a promising future and had high hopes for all her female students. The subjects at the school included German literature, art, history, mathematics, and poetry. Many of the subjects were taught by Anneke herself. She also acted as president of the school. (Courtesy of the Wisconsin Historical Society.)

On a trip to Boston in 1859, Margarethe Schurz, with her children in tow, met Elizabeth Peabody. Peabody, a strong voice in the Transcendentalists, was shocked by the good behavior of the Schurz children on the trip. Schurz explained they were raised in a kindergarten. Schurz was the first kindergarten teacher in the United States, opening the very first kindergarten in her home in 1910. (Courtesy of the Wisconsin Historical Society.)

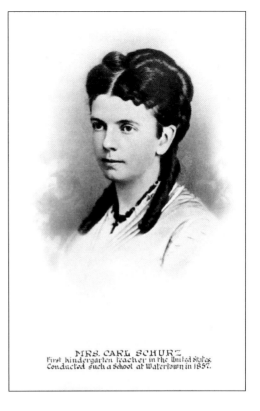

MRS. CARL SCHURZ
First kindergarten teacher in the United States.
Conducted such a School at Watertown in 1857.

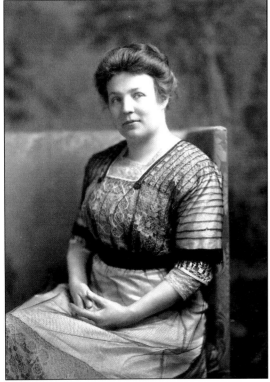

Meta Berger was born in 1873 to German immigrants in Milwaukee. Berger was one of the most prominent women in political, social, and educational circles. She was said to have been "quite as good a socialist as her husband." She did, however, renounce her membership with the party in 1940 after disputes with party leaders. She would go on to have an active political career in the city, receiving honors such as membership on the state roll of honor. (Courtesy of the Wisconsin Historical Society.)

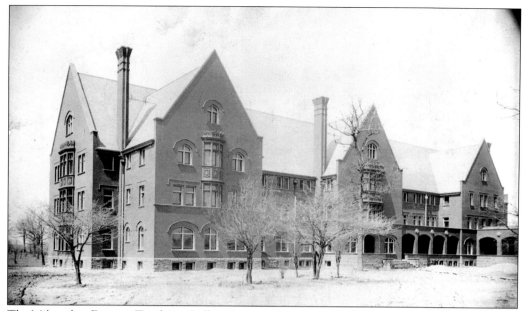

The Milwaukee Downer Teaching College (pictured here around 1853) was attended by prominent women in Milwaukee such as Meta Berger. Berger would return to the Downer Teaching College as an instructor after earning her degree, and later she would return as a member of the Milwaukee School Board. She went on to become a member of the University of Wisconsin Board of Regents and the state board of education. (Courtesy of the Wisconsin Historical Society.)

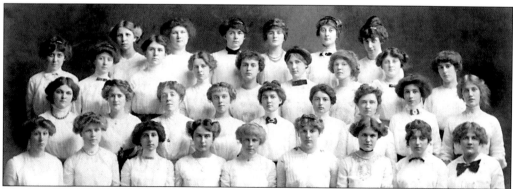

These are the graduates of the women's Milwaukee Downer Seminary in 1912. This was a private girls' junior and high school in Milwaukee attended by many German American women. In 1963, the Milwaukee Downer Seminary merged with the Milwaukee Country Day School and the Milwaukee University to form the University School of Milwaukee. (Courtesy of the Milwaukee County Historical Society.)

Eight

GERMAN AMERICANS DURING WARTIME

The experiences of German Americans in Milwaukee during wartime played a key role in shaping the group's values, as well as its assimilation into American culture.

Wisconsin furnished 15,709 German soldiers throughout the Civil War, many of them from Milwaukee. The 9th, 18th, 26th, and 34th Wisconsin Regiments were almost entirely German. A whole company in the 2nd Wisconsin was German, and the Schuetzen Company in the 5th was made up of members of the Turner Society. Milwaukee enjoyed a large influx of immigration in the ensuing years of peace that followed the Civil War, and its reputation as a German American city became better known on a national level.

When war broke out in Europe in 1914, Milwaukee supported Pres. Woodrow Wilson's isolationist policies wholeheartedly. Many Milwaukeeans, however, were unconvinced of the sincerity of Wilson's neutrality. When the United States entered the war in April 1917, Milwaukee became a home front flash point for attacks on German Americans. People of German ancestry would be forced to sign "loyalty pledges." Vigilantism against Germans was also a serious problem, so much so that Gov. Emanuel Lovenz Philipp had to make several impassioned pleas against the practice. A movement to ban the teaching of German altogether sprang up, and German foods like sauerkraut, frankfurters, and hamburgers underwent name changes to become liberty cabbage, hot dogs, and liberty steak.

As the United States entered World War II, the Milwaukee German community was still recovering from World War I and was struggling to regain some of its former luster. For the most part, the Anglo-American community in Wisconsin did not hold animosity toward Milwaukee Germans for the actions of Adolf Hitler in Europe, and the community was left largely alone throughout the war. Yet the realities of war on the home front passively encouraged assimilation. Many Milwaukee German Americans emerged from the war proud of their efforts to defeat Nazism and feeling a new sense of patriotism because of their wartime accomplishments.

War played a very important role in the shaping of the Milwaukee German community and also in its Americanization as pressure to assimilate was consistently high during wartime.

—Jeanette S. Brickner

The 26th Wisconsin Infantry, part of the 11th Corps, was organized in Milwaukee in 1862 and was primarily German. A large number of the enlisted men were also members of the Turner Society. The regiment suffered one of the highest fatality rates out of the entire northern army, ending the war with 266 total casualties, fighting at Fredericksburg, Chancellorsville, Kennesaw Mountain, and William Tecumseh Sherman's march through Georgia. This photograph was taken at the dedication of the memorial at Gettysburg that now stands near Cemetery Ridge. (Courtesy of the Milwaukee County Historical Society.)

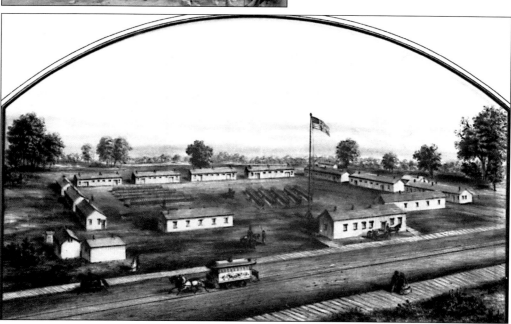

Troops training in Milwaukee during the Civil War were stationed at Camp Sigel, illustrated above. The camp was located near the lake and was named after Gen. Franz Sigel, a German-born 48er who commanded the predominantly German 11th Army Corps during part of the war. "I fight's mit Sigel" became a catchphrase for German troops. (Courtesy of the Wisconsin Historical Society.)

Carl Schurz of Watertown was a Milwaukee lawyer and a 48er who made his mark in numerous fields throughout his life. He played a prominent role in the early Republican Party and went on to distinguish himself as a general during the Civil War. He commanded a division in the 11th Corps and later served as William Tecumseh Sherman's chief of staff during the march through Georgia. (Courtesy of the Milwaukee County Historical Society.)

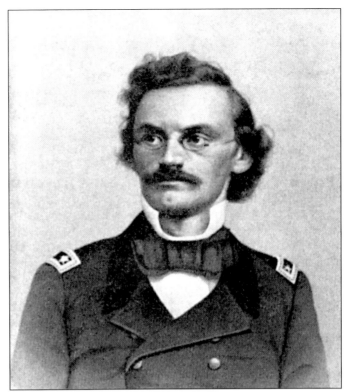

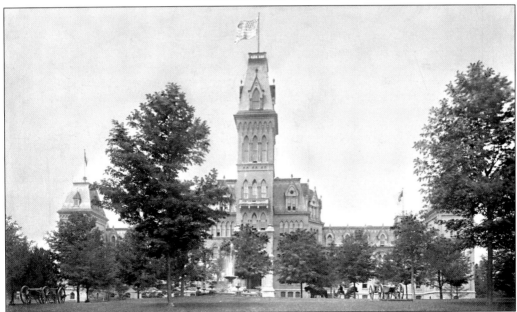

This picture of the Wisconsin Soldier's Home was taken sometime after the Civil War. The building is located on the grounds of the Clement J. Zablocki VA Medical Center campus in Milwaukee. The home served as a refuge for Civil War veterans who were destitute and disabled because of the war. Many German American veterans lived the rest of their lives out in this building. (Courtesy of the Milwaukee County Historical Society.)

This section of panorama of Missionary Ridge, the site of a bloody Civil War battle, was finished by William Wehner's American Panorama Company of Milwaukee in 1884. Wehner noted the popularity of battle-themed panoramas in Europe after the end of the Franco-Prussian war and brought artists from Germany to Milwaukee to craft these battle scenes. Civil War scenes proved to be some of the most successful panoramas of their day. (Courtesy of the Wisconsin Historical Society.)

Emil Seidel, the first socialist mayor of Milwaukee, held the office from 1910 to 1912. He, like most other socialists and German Americans in the city, was in favor of the United States maintaining a policy of isolationism. This poster is advertising an antiwar rally in December 1917, several months after the United States entered the war. (Courtesy of the Wisconsin Historical Society.)

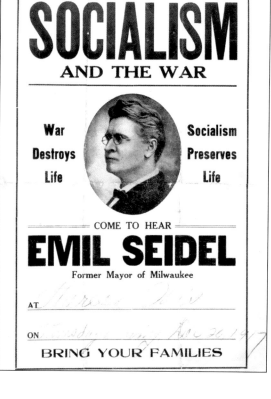

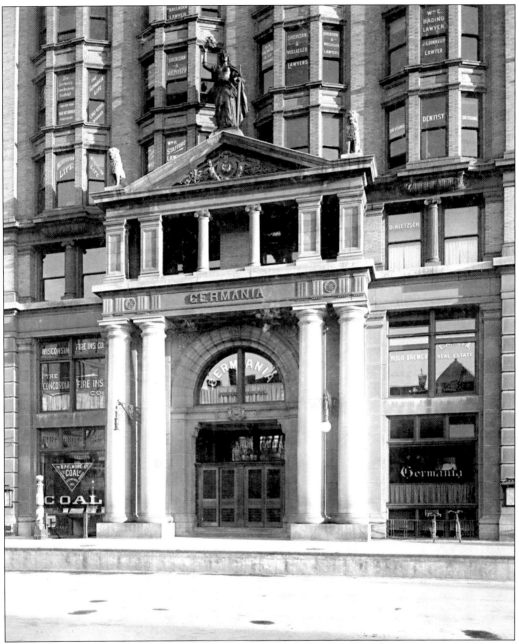

The statue of the goddess Germania once crowned the entrance to the Germania Building in downtown Milwaukee. It was removed by the Austrian American artist Cyril Colnik during World War I to prevent defacement. Legends abound as to what became of the statue, with some claiming that it is still hidden somewhere. Others suggest it may have been melted down. Its fate remains a mystery to this day. (Courtesy of the Milwaukee County Historical Society.)

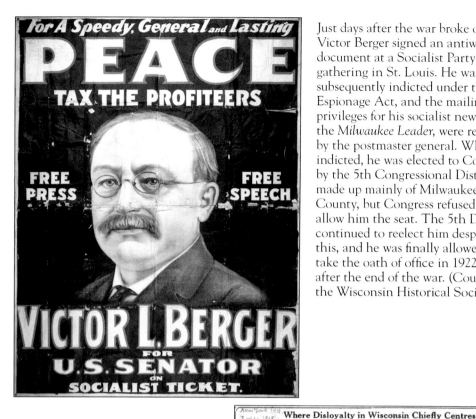

Just days after the war broke out, Victor Berger signed an antiwar document at a Socialist Party gathering in St. Louis. He was subsequently indicted under the Espionage Act, and the mailing privileges for his socialist newspaper, the *Milwaukee Leader*, were revoked by the postmaster general. While indicted, he was elected to Congress by the 5th Congressional District, made up mainly of Milwaukee County, but Congress refused to allow him the seat. The 5th District continued to reelect him despite this, and he was finally allowed to take the oath of office in 1922, long after the end of the war. (Courtesy of the Wisconsin Historical Society.)

This map of Wisconsin appeared in the *New York Sun* in March 1918 and demonstrates the fear of Germans, especially Wisconsin Germans, being disseminated by groups such as the Wisconsin Loyalty Legion. (Courtesy of the Wisconsin Historical Society.)

The Steinbacher Saloon is seen in 1915. World War I gave the prohibitionist movement the traction it had sought in Wisconsin politics for so long. The German voting block lost a great deal of clout during the war, allowing the state to ratify the 18th amendment in 1919. Wisconsin did, however, pass the Mulberger Act in 1919, which allowed beer containing less than 2.5 percent alcohol to continue to be sold. (Courtesy of the Wisconsin Historical Society.)

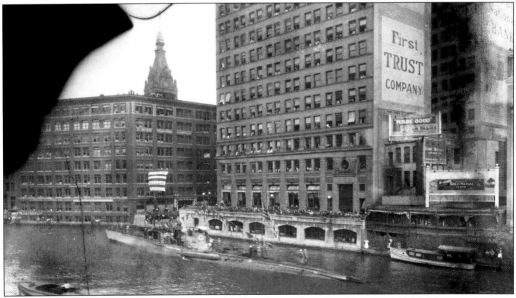

An American submarine was photographed in the Milwaukee River in 1919. During the war, mass hysteria ran rampant throughout the city. With the submarine being a new and somewhat mysterious form of warfare, some people irrationally believed that German U-boats of the time were capable of reaching Milwaukee and planting operatives. The outlandish delusion of U-boats having the ability to penetrate the inland United States was still present during World War II. (Courtesy of the Wisconsin Historical Society.)

This picture is from an Americanization pageant held in 1919. In the aftermath of World War I, nativist groups sought to better assimilate Milwaukee's foreign population. An Americanization Council was formed to promote citizenship. The memory of the mistrust of immigrants during the war and anticommunist hysteria were the driving forces behind this movement. Germans were particularly suspected to have Communist leanings, since Karl Marx had been a German. (Courtesy of the Wisconsin Historical Society.)

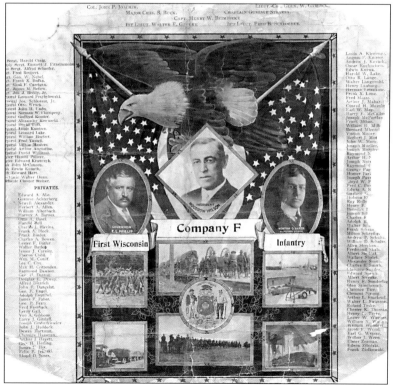

In the hysteria surrounding World War I, simply having a German surname could draw suspicion by the Wisconsin Defense League and similar groups. Over 200 people anglicized their last names in Milwaukee in just the first few months of the war. A glance at the rosters of Wisconsin's soldiers, however, reveals that perhaps as many as half of Milwaukeeans who patriotically served were of German descent. (Courtesy of the Milwaukee County Historical Society.)

As during the Civil War, a Republican Milwaukee German happened to be governor of the state at the outbreak of World War II, Gov. Julius P. Heil. He was born in Duesselmond an der Mosel, and his parents immigrated to Milwaukee in 1880 when he was a young child. In the 1939 gubernatorial election, he was overwhelmingly supported by Milwaukee Germans, and policies helped bring a large number of German Catholic voters into the Republican Party. The Heil Company, which he had founded in Milwaukee in 1901, geared its production toward the military after 1941 and manufactured a diverse array of useful products, including torpedo tubes and pontoon bridges, throughout the war. Here a female employee welds gasoline trailer tanks at the Heil Company in 1943. (Right, courtesy of the Wisconsin Historical Society; below, courtesy of the Milwaukee County Historical Society.)

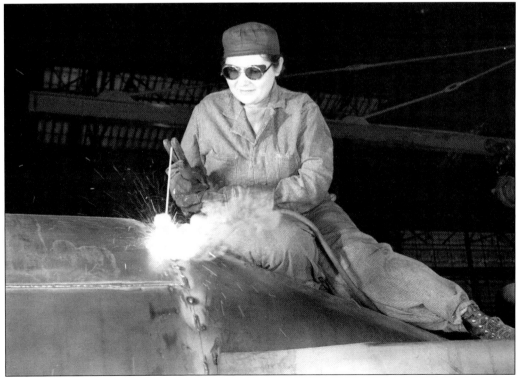

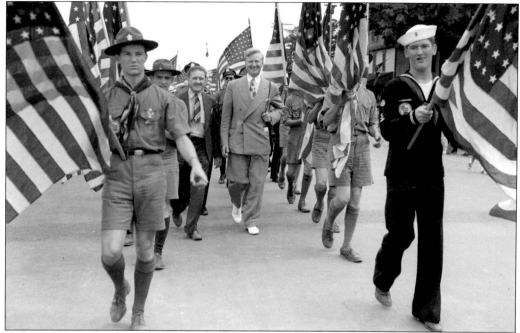

Carl Zeidler, known as Milwaukee's "singing mayor," beat six-term socialist Daniel Hoan in the 1940 election. He filled the office for only a little over a year, however, choosing to accept a commission as a lieutenant in the naval reserve shortly after World War II broke out. Above, his charisma is perceptible as he marches in a parade. Below, he is swearing in a group of cadets in the Plankinton Building on Wisconsin Avenue. The young Carl Zeidler had caught the attention of many national politicians and was expected to return from the war to a bright political future, perhaps on a national level. Sadly, the ship on which he served, the SS *La Salle*, went missing in December 1942. (Courtesy of the Milwaukee County Historical Society.)

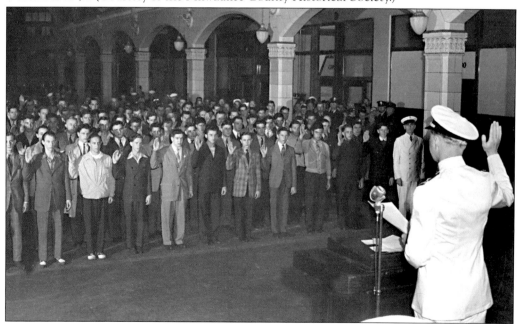

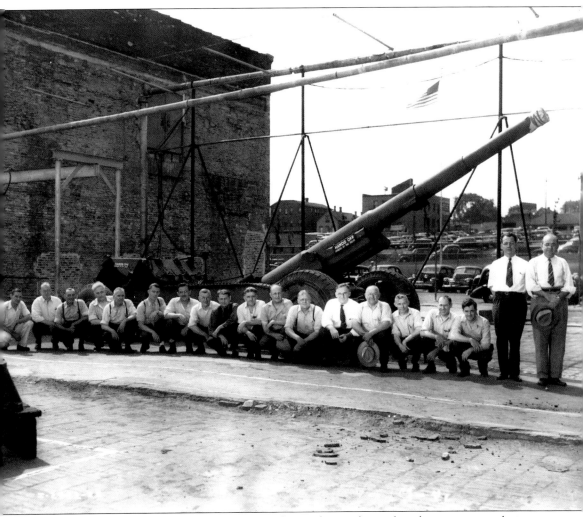

This photograph shows Milwaukee workers in front of a newly produced gun carriage during World War II. Milwaukee companies like Harnischfeger, Milwaukee Works, and many others were involved in war production, making everything from steel tank cars to howitzers. Later in the war, women could frequently be found working the lines and took great pride in their contributions to the war effort. Many of these workers were of German descent. (Courtesy of the Wisconsin Historical Society.)

Discover Thousands of Local History Books Featuring Millions of Vintage Images

Arcadia Publishing, the leading local history publisher in the United States, is committed to making history accessible and meaningful through publishing books that celebrate and preserve the heritage of America's people and places.

Find more books like this at
www.arcadiapublishing.com

Search for your hometown history, your old stomping grounds, and even your favorite sports team.

Consistent with our mission to preserve history on a local level, this book was printed in South Carolina on American-made paper and manufactured entirely in the United States. Products carrying the accredited Forest Stewardship Council (FSC) label are printed on 100 percent FSC-certified paper.